Bonnie Hutzmann

Betty Slechman

Our Critter Queen has a special friend who contacts her with two swoosh-swooshes of her tail. Her name is Crystalina, a very sweet and delicate mermaid who came from the Gulf of Mexico. She loves the Coast and stays very busy all the time. Sometimes you can see Crystalina and her Mermaid friends splash and play in the waves.

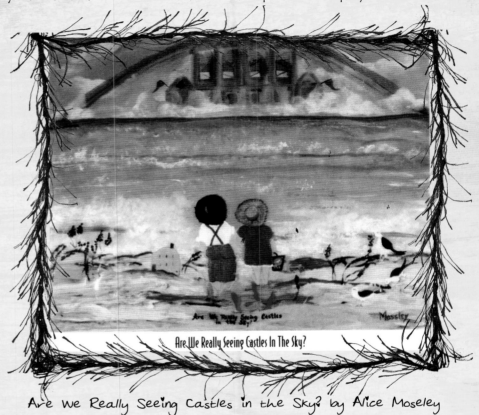

Are We Really Seeing Castles in the Sky? by Alice Moseley

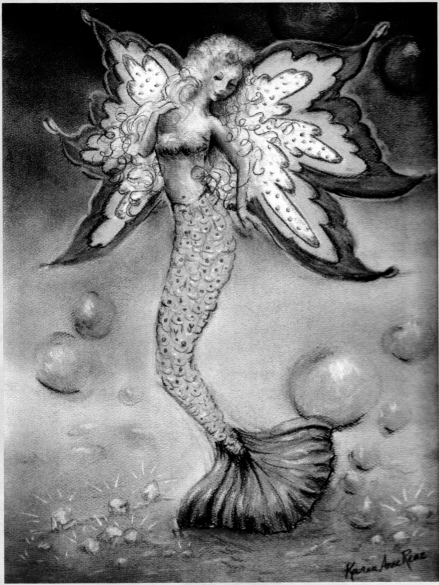

CRYSTALINA BY KAREN RENZ

She loves to catch rides on the speedy dolphins to see the glistening sun. Crystalina especially likes when the rain creates many little beautiful rainbows that touch each other. She is quite certain that this is the time when dreams and wishes come true. Crystalina hopes to see each of you enjoy our beautiful coastlines. She reminds us to please take care of them for all to enjoy. Remember, Swoosh-Swoosh. She is just a smile and a wave away.

— CONNIE HEITZMANN and martha merrigan

DEDICATIONS

betty- I would like to dedicate our book to my wonderful late husband, Ted Stechmann. He would have been proud of this community and how we survived Katrina. I also dedicate it to my children, Derek Stechmann, the late Daren Stechmann, Beth Coleman, and my beautiful grandkids, Jacob, Robert, Jade, and Kailey.

connie- I dedicate our book to my wonderful husband, Bob. My life is surrounded by his unending love, talent, and support in everything I do. I dedicate it to my son, Matt, Ashley, my sweet daughter-in-law, and Ms. Annie.

THANK YOU FROM BETTY AND CONNIE

We would like to thank everyone for all the cherished memories that inspired our wonderful book, as we reflect on our local residents, visitors, and, of course, all of the beloved volunteers and you. God Bless You All!

SCOTT BLACKWELL

SANDY BELCHER

Connie Heitzmann and Betty Stechmann have co-authored a unique book called *Scrapbook of Treasured Memories*. It is a book about the Gulf Coast. This keepsake volume contains guest artwork, guest photography and guest writing from many gifted and generous friends across the Coast. They have all taken their time to help make our book a great success. The memories depicted celebrate the treasures we share on the Gulf Coast through its people, places, and past places and fun. Hope you enjoy and remember and visit all of our wonderful friends. They have so much to share with YOU.

Copyright © 2008 Connie Heitzmann and Betty Stechmann

All rights reserved

Cover and Interior Graphic Design by Rachel Winters

Front Cover Artwork by Karen Renz

Back Cover Photo by Ken Murphy

Printed in South Korea

All contributions for publication are in accordance to copyright standards and regulations to the best of our knowledge. Every effort has been made to assure the accuracy of this book.

ISBN-13: 978-1-883651-32-9

ISBN-10: 1-883651-32-8

Library of Congress Control Number: 2008936866

editors - Ann Kearney, Betty Stechmann, Connie Heitzmann, Christina Harrelson, Janet Buras, Kay Gleber, Karen Eddy, Kerry Latiolais, Konnie Duncan, Martha Merrigan, Phyllis Winters, Tracy Winters, and Rachel Winters

WP Winters Publishing

P.O. Box 501
Greensburg, IN 47240
www.winterspublishing.com
800-457-3230

MERMAIDS OF THE GULF

Mimi Loup Brown

Mary Miller

Ann Kearney

Mimi Loup Brown

Mary Miller

Ode to the Heart of Old Bay St. Louis

Bay St. Louis, a quaint little town
Sat quietly down by the sea.
Her streets were so narrow
That folks in their cars, drove ever so carefully.

THE WAY WE WERE
BY KATHE CALHOUN

The wind softly danced me around every bend
As the sea beckoned me to her side,
And the breath that she gave, coming in on her waves,
Would take mine away on the tide.

The lamp posts on Main Street bearing her name
Cast ever an evening glow
On true love's first glance, and lightened the path
Of many a traveling road.

The bells in the church tower rang in each day
As I'd take a casual stroll.
And I remember a shopkeeper, there in his doorway
Waving a cordial "Hello."

In my quest for pleasure, discovering treasures
In the little shops down by her shore
I found in the Heart of Old Bay St. Louis
That I'd never need look for more,
No ... never need look for more.

- bonné vallery

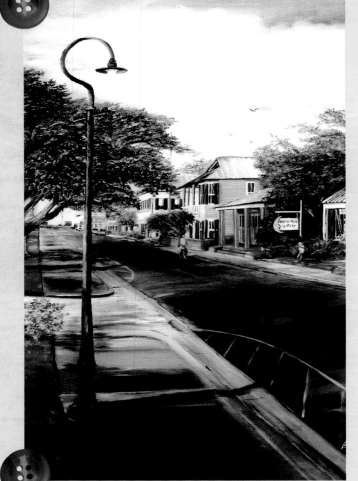

REMEMBER US BY BONNÉ VALLERY

VOID IF DETACHED
For one trip of Class __ vehicle only
Use confined to terms of the
attached contract
BAY ST. LOUIS BRIDGE
BAY ST. LOUIS, MISSISSIPPI
Void after date stamped on back

321317

POSTCARD COMPLIMENTS
OF BETTY STECHMANN

Bay-Waveland Yacht Club by Janie Koch

A Place Where Children live a dream –
Swimming, Sailing, Fishing, and
Crabbing until the last summer's sunset.
As Adults we realize that we are blessed
with a great life on the Bay, and we
promise to preserve and enhance the
dream for our children and grandchildren.

- john m. rosetti, III

Tucked in the Bay of St. Louis is
hidden treasure filled with tradition
and fun, not only for yachtsmen,
but all who enjoy being by the water.
It is the Bay-Waveland Yacht Club
founded in 1896, host and winner of
many sailing championships.

- martha merrigan

I have watched the New Bay Bridge go up via the internet webcam! Congrats
and thanks to ALL those who made that possible! I can't tell you what it
means to SEE that bridge stand again! I am so grateful to have taken some
"before" pictures, that will always warm my heart; just as the sight of the new
bridge gives me hope and pride in my home and the people, who determine
the future by their everyday efforts, as they raise again!

God Bless You All!

- ann o'toole, Austin, TX

Bay St. Louis Bridge by Ann Kearney

5

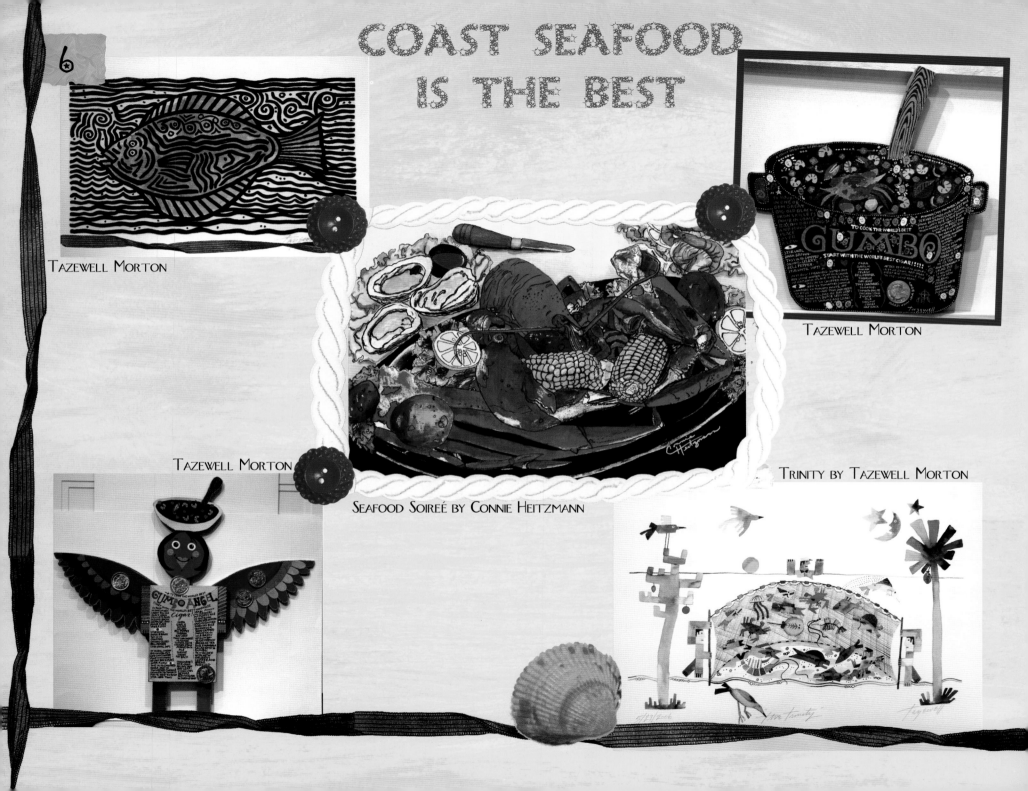

COAST SEAFOOD IS THE BEST

Tazewell Morton

Tazewell Morton

Tazewell Morton

Seafood Soireé by Connie Heitzmann

Trinity by Tazewell Morton

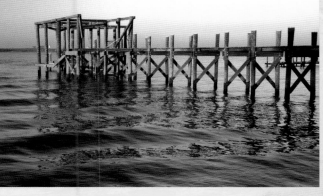

Peaceful Pier by Betty Stechmann

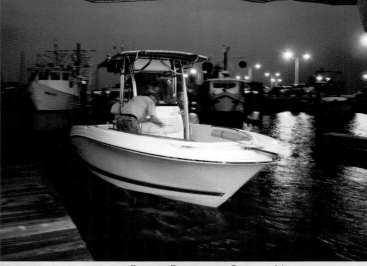

Bob's Boat by Connie Heitzmann
Getting ready for Mississippi Sound Fishing

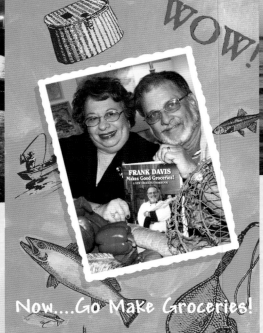

WOW!

Now....Go Make Groceries!

Frank Davis and Mary Clare
Photo & Art by Betty Stechmann

A favorite youthful pastime on the Bay of St. Louis includes that special night spent sleeping on the end of the pier ... fear of rolling off into the surf ... a cool breeze playing with the sheets tightly wound round your legs, and the soft lap of waves calling you to dream.

· suzi hand

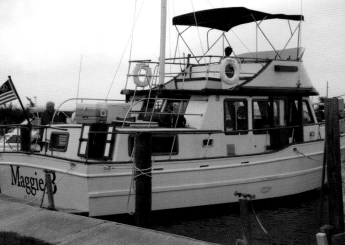

Maggie B – Chuck and Ellen's Boat by Connie Heitzmann
Chuck's trawler makes cruisin' the St. Louis Bay easy.

BAY—BOOKS

Antique Maison

by Barbara Brodtmann

Rutherford Pier

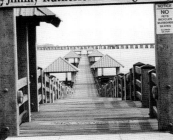

Sea Coast Echo

MUNICIPAL PIER
CITY of BAY ST. LOUIS

BAY ST. LOUIS

Nancy McCardell

Kate Lobrano House

Hancock County Historical Society
by Betty Stechmann

Irene Thomas Berry & Betty Smith Stechmann
Hancock County Historical Society &
Pat Murphy Archives

In the '50's, the Hummingbird Train
would stop briefly at 2:20, when
commuting passengers would have a
chance to buy pralines and stuffed crabs.

Bay St. Louis Train Depot by Janie Koch

KAYAKS and BIKES

Da' Beach House by Betty Stechmann

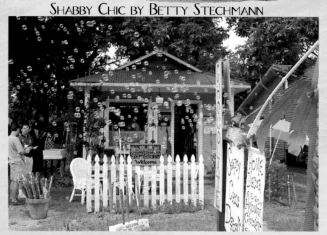

HURRICANE CROSS BY
DEVON WESTON

Stennis Space Center NASA –
Celebrating 50 years

witness protection

There's a new program on TV called "In Plain Sight."
It's about witness protection,
and it strikes a chord in our hearts.
You see, we feel somedays like WE'RE in a witness protection program.
OK, we haven't had to change our names,
and our family and friends know where we are.
Still, we're strangers in a strange land –
in a new home we didn't choose to have,
surrounded by people who don't know us,
who don't know who we were, what we are.
We're making a new life, starting over, if you will,
but it's not "home."
The climate here is pleasant, and the environs are pleasant.
We feel safe here.
Most days, we're content – grateful for what we have.
But we long for the Coast – the beautiful sights of the Mississippi Sound, the
restaurants, art galleries, wonderful sense of community – and most of all,
our long-time friends in a place that we intended to end our days.
So, some days, we feel banished, isolated – two fugitives, refugees,
thrown adrift by Mother Nature –
two of the thousands who witnessed that monstrous crime
known throughout the world as Hurricane Katrina.

• nan and dick ehrbright

We miss you guys and
hope you hurry
back home.

– Betty, Connie, and our
Community

See ya'll at the New Home of
Bay St. Louis Little Theatre.

Site of the 1965 movie
"This Property Is Condemned."

Bay St. Louis Little Theatre
by Betty Stechmann

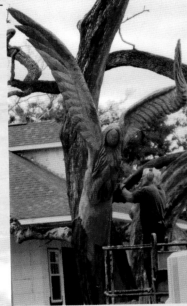

Dayle Lewis Carving the
Angels of Demontluzin St.
by Vicki Niolet

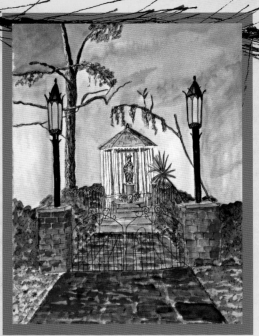

OUR LADY OF THE WOODS
BY JANIE KOCH

BY BETTY STECHMANN

ST. AUGUSTINE SEMINARY, SVD –
THE GROTTO BY JO ANN HILLE

"Habitat" presented to Jimmy and Rosalynn Carter
by Habitat for Humanity Bay-Waveland and artist Lori K Gordon
in appreciation for their efforts rebuilding the
Mississippi Gulf Coast following Hurricane Katrina.
May 2008

HABITAT BY LORI K. GORDON

PRES. JIMMY & ROSALYNN CARTER WITH LORI K. GORDON
Photo by Ellis Anderson

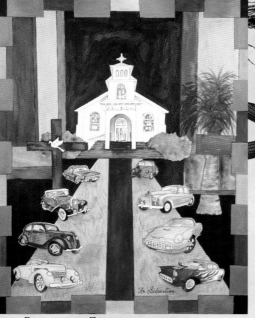

There are several factors that motivated me to paint this picture. It was an attempt to capture things that we experienced in the form of destruction, faith that kept us focused, Church, faith-based and civic organizations that came to our assistance, individuals who helped, volunteers who reached out, and agencies (both governmental and non-governmental) who played a vital role in the process of recovery.

- father sebastian myladiyil, svd
PASTOR OF ST. ROSE DE LIMA CATHOLIC CHURCH

DRIVEN BY FAITH
BY FATHER SEBASTIAN MYLADIYIL, SVD

BEAN THERE – COMING BACK! BY DWIGHT ISAACS

Optimism reigns on the Gulf Coast.
Despite the destruction, Faith keeps us afloat.
Light shines in the darkness,
and with Divine help, we recover.
Artists envision Angels and peace around us
And our churches are "Driven by Faith."
We've had a wild ride,
but antique cars still cruise the coast,
Harleys abound, and our spirits are high.
We've "Bean There," and we're Coming Back!

- angelyn treutel

Can Bayou Pierre et Jean really be the final resting place of the illusive Lafitte brothers? Legend bequeaths this distinction to the famed bayou off North Beach Boulevard where they may lie, not only the remains of the men, but also their vast treasures.

- charles gray

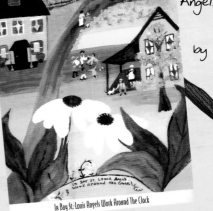

In Bay St. Louis
Angels Work Around
the Clock
by Alice Moseley

JEAN AND PIERRE LAFITTE BAYOU
BY SANDY BELCHER

ANTIQUE CAR BY PATSY SEELING

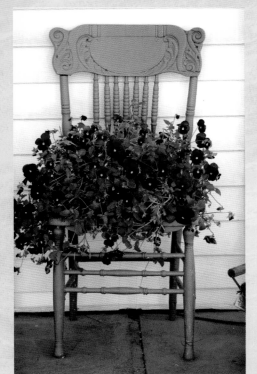

Bay St. Louis Blues by Paul Eddy

Marilyn Heitzmann Cardenas

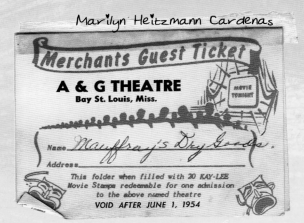

Merchants Guest Ticket

A & G THEATRE
Bay St. Louis, Miss.

Name Mauffray's Dry Goods.

Address

This folder when filled with 20 KAY-LEE
Movie Stamps redeemable for one admission
to the above named theatre
VOID AFTER JUNE 1, 1954

The House is Blue but the Old Lady Ain't
by Alice Moseley

Pewter, the Cat by Karen Eddy

12

"Be Our Guest"

SECURE YOUR KAY-LEE MOVIE STAMPS
FROM THE FOLLOWING MERCHANTS

GULF CHEVROLET CO., 120 S. Beach

BUFKIN RADIO & TV, 210 N. Second

KERN'S 5 & 10c STORE, 131 Main

AUTO-LEC ASSOCIATE, 116 S. Beach

MAUFFRAY DRY GOODS

MAGNOLIA STATE SUPPLY CO., 111 Main

JITNEY-JUNGLE - SELF SERVICE FOOD STORE

Marilyn Heitzmann Cardenas

A&G Theatre
by Betty
Stechmann

bay st. louis

Take a stroll through today and yesterday
With colors and critters in the St. Louis Bay.
Remember what fun a movie could be
When merchants gave free tickets to you and me.
Miss Alice Moseley's art full blue house
And Starfish can be found
In this beautiful little coastal town.

- karen eddy

The Caboose Gallery

Long Beach, Mississippi

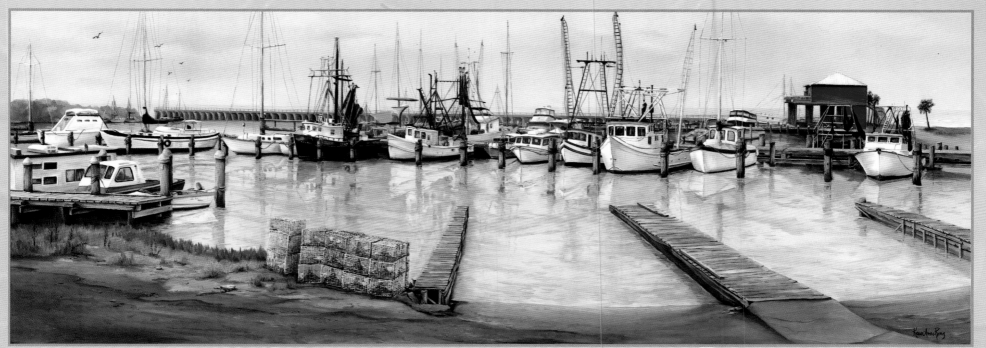

THE CALM BEFORE THE STORM BY KAREN RENZ

Bumped up snugly against Highway 90, on the deepest part of the Mississippi coastline, sits picturesque Pass Christian Harbor. The sterns of vessels are so close to the road that their christened names can be easily read from car windows stopped at the red light. As one tools down the needle-eyed driveway toward the newly rebuilt Yacht Club, a bustle of activity from both sailors and shrimpers is evident. The smells of fresh catches, along with the changing of loose halyards excite the senses. Space is tight, so seamen, both commercial and pleasure, are called to stay alert. At the end of the day, yachtsmen head home with bonus souvenirs of salty skin and mousse-like hair.

- mary ladner benvenutti

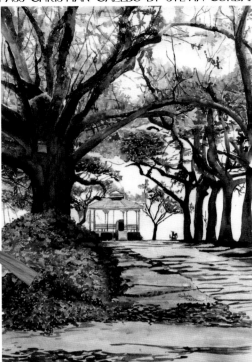
Gulf Coast White Pelican by Connie Heitzmann

Pass Christian Gazebo by Sylvia Corban

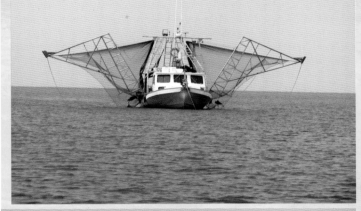
Shrimpers Sleeping by Connie Heitzmann

Beach Babies by Betty Stechmann

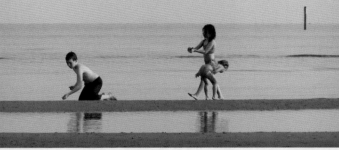

14

THE DRACKETT FERRY
HANCOCK HISTORICAL SOCIETY

FERRY

The Drachett Ferry which operated between Henderson Point and Bay St. Louis until 1928 presented quite a surprise to guests on Saturday nights. At midnight in mid-bay, her anchor was lowered and a band appeared. The passengers danced until daybreak.

- charles gray

THANKS LARRY LARROUX & GARY TAYLOR

BAY ST. LOUIS BRIDGE - U. S. HIGHWAY NO. 90
BAY ST. LOUIS, MISSISSIPPI
COMMUTER'S TOLL FEE
COUPON BOOK
COUPONS ARE VOID IF DETACHED

Issued under conditions of contract

40 COUPONS
PRICE $2.00

Bridge Supt. Signature

Date Issued

BOOK NO. 321317

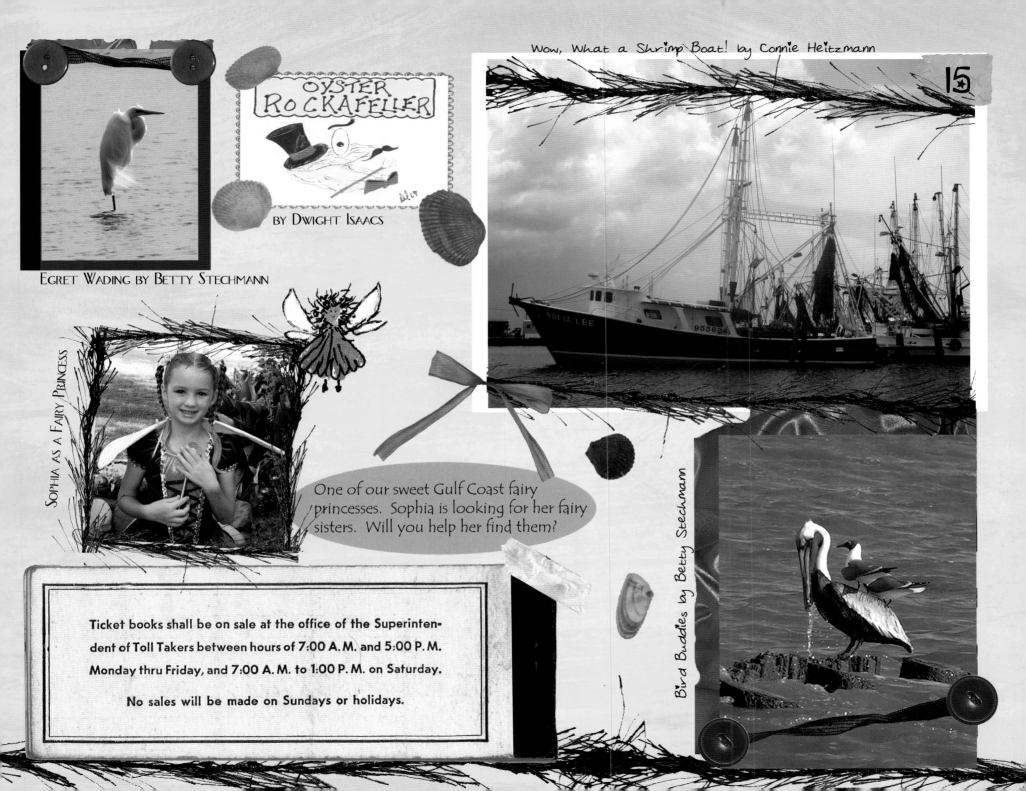

Wow, What a Shrimp Boat! by Connie Heitzmann

OYSTER ROCKAFELLER

BY DWIGHT ISAACS

Egret Wading by Betty Stechmann

Sophia as a Fairy Princess

One of our sweet Gulf Coast fairy princesses. Sophia is looking for her fairy sisters. Will you help her find them?

Bird Buddies by Betty Stechmann

Ticket books shall be on sale at the office of the Superintendent of Toll Takers between hours of 7:00 A.M. and 5:00 P.M. Monday thru Friday, and 7:00 A.M. to 1:00 P.M. on Saturday.

No sales will be made on Sundays or holidays.

SOFIA LEE 955624

Pass Christian Harbor by Janie Koch

Red Hats on the Ferry by Janie Koch

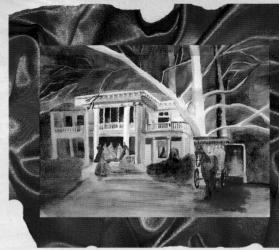

The Chimney's by Janie Koch

Shaggy's by Janie Koch

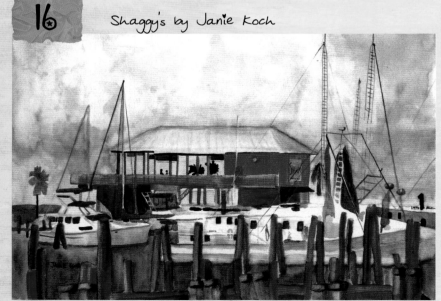

Pirate's Cove by Janie Koch

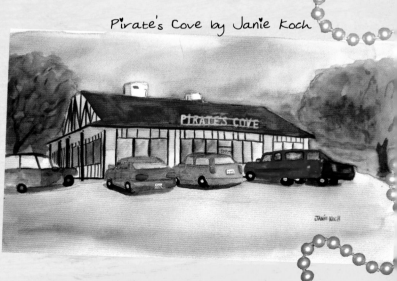

the ferry

What a fun time we had
On the ferry that Day.

Our Red Hat Ladies
Took a cruise on the bay

The ferry's now gone
But that's alright

Our new bridge is better
To run, walk or bike.

-Janie Koch

THE CASTLE HOUSE BY DOT COPELAND

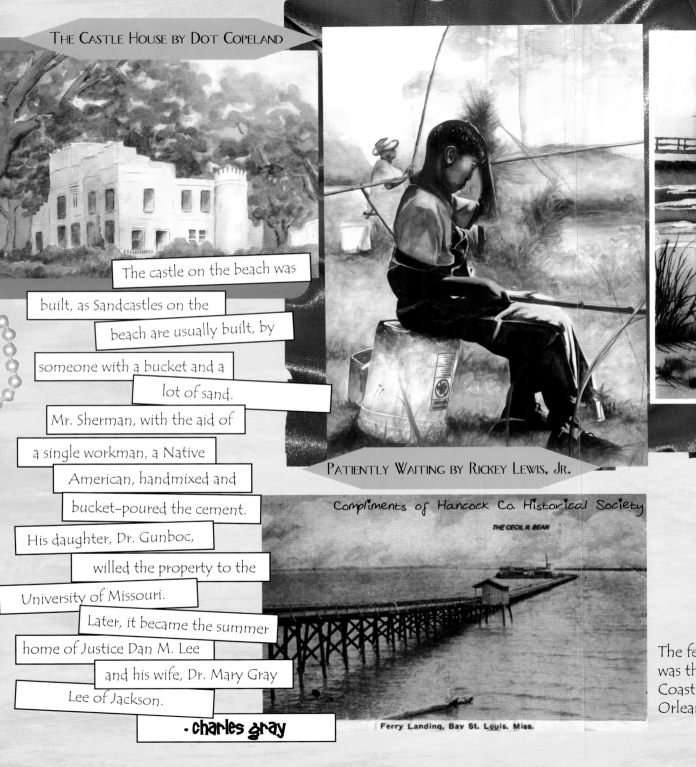

The castle on the beach was

built, as Sandcastles on the

beach are usually built, by

someone with a bucket and a

lot of sand.

Mr. Sherman, with the aid of

a single workman, a Native

American, handmixed and

bucket-poured the cement.

His daughter, Dr. Gunboc,

willed the property to the

University of Missouri.

Later, it became the summer

home of Justice Dan M. Lee

and his wife, Dr. Mary Gray

Lee of Jackson.

- charles gray

PATIENTLY WAITING BY RICKEY LEWIS, JR.

Compliments of Hancock Co. Historical Society

THE CECIL N. BEAN

Ferry Landing, Bay St. Louis, Miss.

PIER BY SYLVIA CORBAN

SEAGULL SMILING BY BETTY STECHMANN

The ferry landing at Demontluzin Street was the connection to the rest of the Coast, or traffic from those places to New Orleans.

- charles gray

OLD CUEVAS BISTRO
BY JANIE KOCH

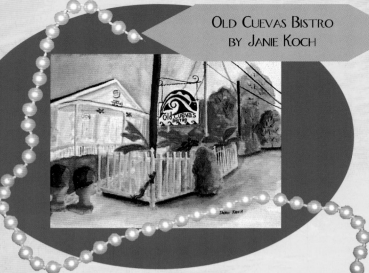

Old Cuevas Bistro is a welcome site.
You can bet Casandra is cooking up a delight.
The building is old and historical because
Cuevas Post Office and trade store it was.

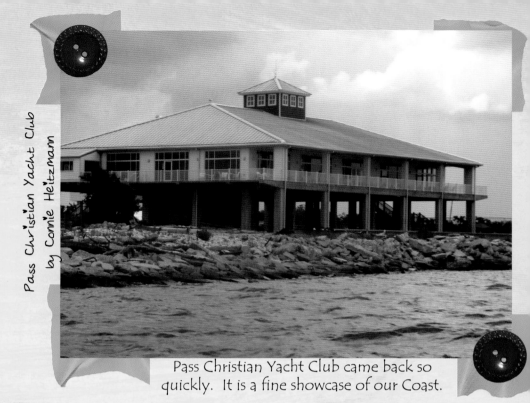

Pass Christian Yacht Club
by Connie Heitzmann

Pass Christian Yacht Club came back so
quickly. It is a fine showcase of our Coast.

Gotcha! by Connie Heitzmann

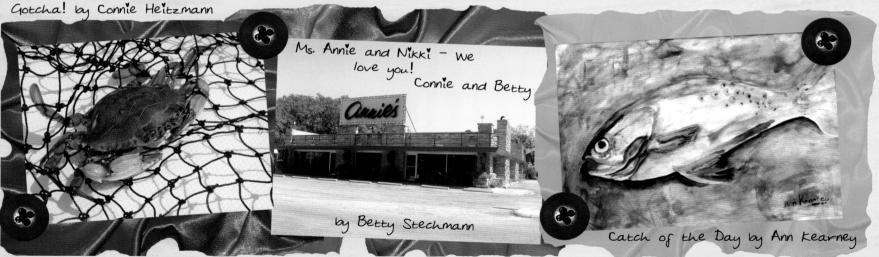

Ms. Annie and Nikki — We
love you!
Connie and Betty

by Betty Stechmann

Catch of the Day by Ann Kearney

The Gulf Coast is known for its delicious, delectable, luscious, savory, unique cuisine. It has a wonderful mixture of French, Cajun, Spanish, Mexican, and, of course, Southern seasonings and flavors. We have seafood gumbo, shrimp Creole, shrimp poboys, roast beef poboys, catfish, jambalaya and southern fried chicken, to name only a few. These delightful dishes will satisfy the desires of anyone and have them come back for more.

• christy carter

Thirty-three years ago, I moved to Waveland with five children, five suitcases, a dog named Queenie and a female cat named Charlie. It was the BEST move I ever made in my life!! I couldn't have found a better place to raise my five children. They could walk the 2 blocks to the beach, and go swimming and fishing with numerous friends. They learned how to "gig" flounders and catch crabs (both hard shell and soft shell), that we'd stay up late cooking and eating. My social life revolved around Peterman's Wash-a-teria, until I got my own washer and dryer a year later. I met almost all of the people in town there on Coleman Avenue, and if any of the children needed medical attention, I'd usually go and get Mrs. Louise Lynch's (who owned the local drug store) advice, before heading to the doctor's office. I loved visiting with Mrs. Jane Mollere at her Hardware Store, too. Between their two shops, you could pretty much find out what was happening all over Waveland.

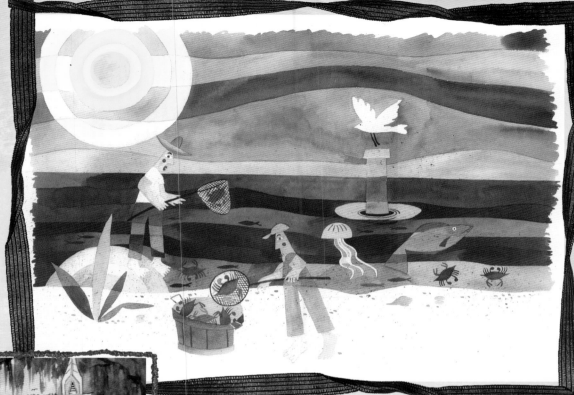

NIGHT CRABBING BY TAZEWELL MORTON

But the most fun of all was to join the Waveland Players!! The cast members were led by Teddy, Betty, Edith, Barbara, Nan, Dick, Martin, Ed, Picolla, the St. Stan Barber Shop Quartet, etc. Some of them have moved on to "higher performances" now, but they will never ever be forgotten!! Before seeing the latest Players Variety Show, you could grab a bite to eat at Haverty's, Ricky's, Dempsey's, or Jack's Restaurant. You couldn't go wrong with any Coleman Avenue eatery. You might have encountered some performers at any of these fine establishments at any point in time.

- margo frommeyer

WAVELAND BY KATHE CALHOUN

BB's Bar-B-Que by Betty Stechmann

Although the beach, the parades, the food, and the unexpected things like the night sky along the beach being filled with holiday fireworks held a charm that kept us glued to this place; I soon discovered the real secret charm of Waveland - its people. There is such a generosity of spirit here. Waveland is called "the hospitality city." Webster's defines hospitable as "given to generous and cordial reception of guests." Well, there you go!

Night Fishing by Tazewell Morton

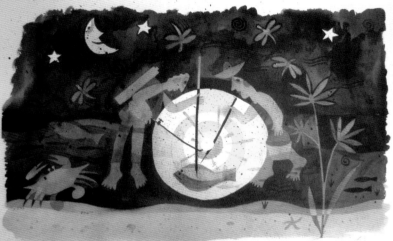

My husband, Ron, and I love Waveland and think it is the ideal place to live, play, retire and work. It is a quiet place where people know your name and treat you like a friend. If you are one of those who crave city lights, sidewalks, and fast lanes, you only have to drive a few miles away to find it. But as for me, I love living here.

- kathy and ron pinn

Rainbow Volunteers by Betty Stechmann

Hubbard's Hardware by Betty Stechmann

That Cute Little Shoppe by Kathy & Ron Pinn

Hop, Skip, and a Jump by Spencer Gray, Jr.

20

Stephen Peterman
Detroit Lions

GRAND MARSHAL STEPHEN PETERMAN

John Forcade (former New Orleans Quarterback) with Bay St. Louis Mayor and Waveland Mayor

Nereids Parade
by Connie Heitzmann

Greeting Governor Barbour
by Betty Stechmann

PHOTO BY JANET BURAS

LAISSEZ

LES BONS TEMPS ROULER

Let the good times roll

CRITTER QUEEN
BY KAREN RENZ

See you at the Mardi Gras

Prissy Pressgrove at Work
by Betty Stechmann

CHRISTINA & CHUCK'S ABBY
PHOTO BY BETTY STECHMANN

MAZIE AS MOTHER TERESA

21

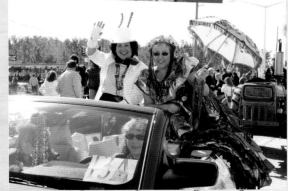

FRECKLES AND CRITTER QUEEN BY BETTY STECHMANN

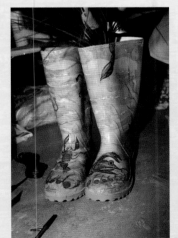

SHRIMP BOOTS ON PARADE
BY BETTY STECHMANN

Prissy by Betty Stechmann

Nereids Crest

NEREIDS

Nereids Maid — Laura Lacour

Nereids Queen Doris XLI and King Charles Johnson, Jr. with Captain Dolores Richmond

22

CAMELLIA BY MARIE KLEIN

EGRET BY JESSICA HOLLAND

WE LOVE CAMELLIA GRILL
BY CONNIE HEITZMANN

PHOTO COMPLIMENTS
OF JANET BURAS
PHOTOART BY
BETTY STECHMANN

CLAY CREATIONS BY JENISE MCCARDELL
PHOTO BY BETTY STECHMANN

BAYOU COUNTRY
IS THE PLACE TO GO.

A Mighty Dragon by Rickey Lewis, Jr.

Wedding at Picayune's Crosby Arboretum
by Sandy Belcher

Sugar and Spice by Betty Stechmann

Gabriella by Jimmy Loiacano

by Heather Wagar

Mares Gossiping on the Fenceline

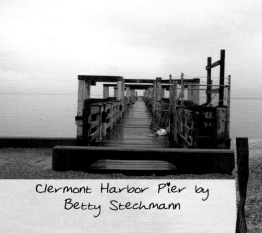

Clermont Harbor Pier by
Betty Stechmann

Conch Shell by Betty Stechmann

Photo by Betty Stechmann

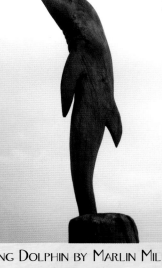

DARLING DOLPHIN BY MARLIN MILLER
PHOTO BY CONNIE HEITZMANN

WOOD CARVING BY MARLIN MILLER
PHOTO BY CONNIE HEITZMANN

How many minutes are there between the time when
the sun drops below the far horizon and darkness
sets in, bringing the mosquitoes? The
perfect time to sit in the cool evening
and reflect upon the day spent playing
on the water. It is a finite moment
with infinite memories.
- suzi hand

Bob's Crab's
OPEN

Photo by Betty Stechmann

Gulf Coast Summer Afternoon by Betty Stechmann

BY CONNIE HEITZMANN

PELICANS ON PILINGS BY BETTY STECHMANN

26

BLUE HERON
BY BETTY STECHMANN

STANISLAUS PIER IS BACK BY MATT HEITZMANN

BEACH SERENITY BY CONNIE HEITZMANN

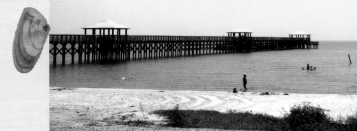

Sailboats in the Sun by Mai Sanders

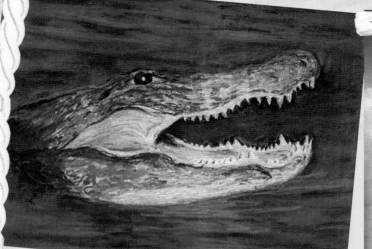

Alligator by Barbara Brodtmann

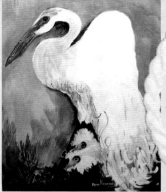

Egret Family by Ann Kearney

Summer Fun by Betty Stechmann

Go Brett by Betty Stechmann

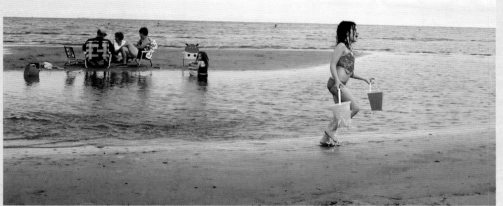

U.S. COAST GUARD, GULFPORT, MS BY CONNIE HEITZMANN

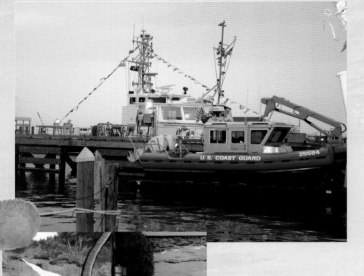

Marine Life Dolphin by Martha Merrigan

28

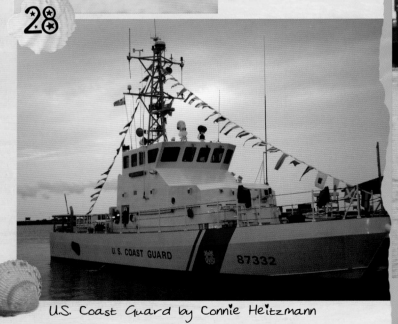

U.S. Coast Guard by Connie Heitzmann

YACHT CLUB – THE CROWN JEWEL OF GULFPORT
PHOTO BY CONNIE HEITZMANN

Martha and Connie visit with Kelly (dolphin) at her new home at Atlantis, Paradise Island, Bahamas.

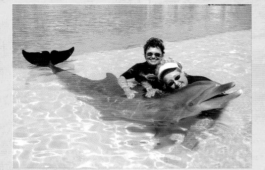

the katrina dolphins · kay gleber

Mississippi Marine Life was the home to eight dolphins. Hurricane Katrina destroyed their home, and the dolphins were swept out into the perils of the open waters of the Gulf of Mexico. They were rescued by a network of people and organizations. Kelly was the fourth dolphin to be rescued, and was provided a safe environment at the Seabee Base in Gulfport, and was joined by three other rescued dolphins. The eight dolphins were moved to a new home in Atlantis, Paradise Island in the Bahamas. The dolphins were recently visited by these ladies, Martha and Connie, from Bay St. Louis.

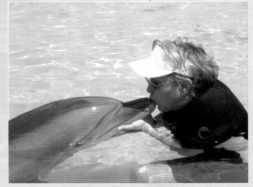

Connie with rescued dolphin, Runner, at its new home at Atlantis, Paradise Island, Bahamas.

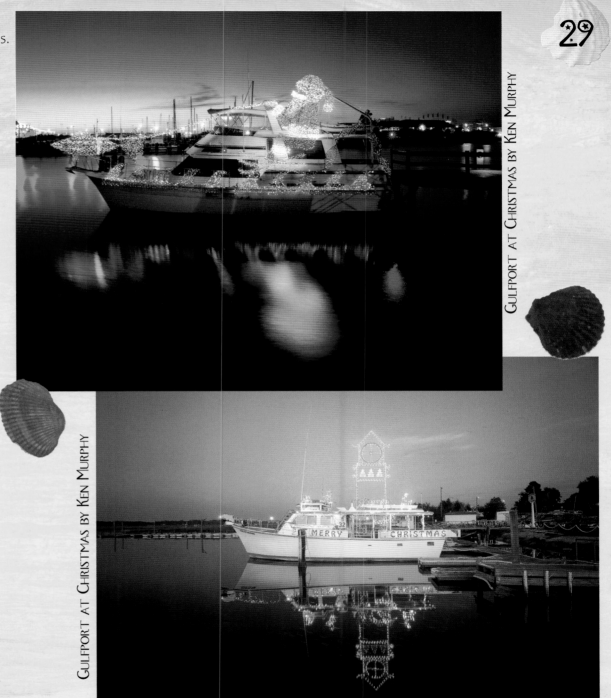

GULFPORT AT CHRISTMAS BY KEN MURPHY

GULFPORT AT CHRISTMAS BY KEN MURPHY

Biloxi Town Green by Ken Murphy

Biloxi Seafood and Industry Museum by Ken Murphy

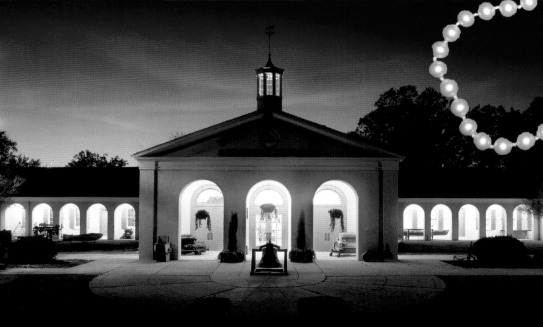

TULLIS MANOR BY KEN MURPHY

BEAUVOIR BY KEN MURPHY

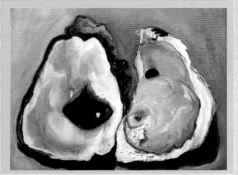

Oysters by Ann Kearney

GEORGE E. OHR

Biloxi's "Mad Potter" was his nickname,
Making pottery was his claim to fame.
George E. Ohr may be gone,
But his works will forever live on.
A museum for his work is on the way
So come on down to Biloxi
And make it a day.

- janie koch

Summer Breeze by Sylvia Corban

32

Ice Cold Fun in Biloxi …
How can this be???
Join in and be cool,
Ice hockey will rule!!
Mississippi Sea Wolves

- angelyn treutel

Seawolves Hockey

GO SEA WOLVES!!

POT-OHR-E

Pot-Ohr-E by Janie Koch

Wood Carving by Marlin Miller
Photo by Connie Heitzmann

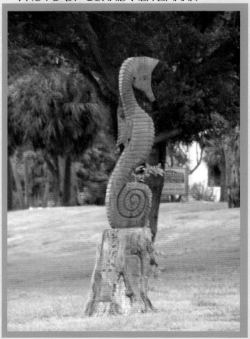

People
P
A
R
T
Y
Page

Jazz Funeral by Tazewell Morton

Carnival Fun by Cherie Hyde

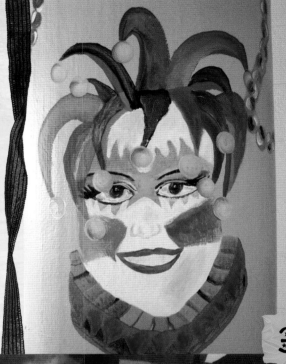

Seafood Gumbo Jazz by Scott Blackwell

SEAFOOD GUMBO JAZZ

HOT & SPICEY

Coffee Club by Tazewell Morton

GONE FiSHiN'

The Gulf Coast is an angler's dream. The freshwater lakes and bayous team with big mouth bass, crappie and catfish big enough to saddle up and ride. Out on the salt, speckled trout, redfish and flounder as wide and flat as a welcome mat abound. Further out, king mackerel, cobia, tuna, and wahoo beckon to the more adventurous sportsman.

FISHING FUN BY SYLVIA CORBAN

Redfish by Sylvia Corban

34

Speckled Trout by Sylvia Corban

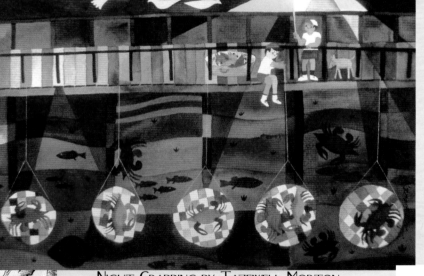

NIGHT CRABBING BY TAZEWELL MORTON

TROUT BY BARBARA BRODTMANN

The best part is - even if you don't catch a thing - you're surrounded by natural beauty, borne aloft on Mother Ocean's graceful waves, and surrounded by friends. It just doesn't get any better than that.

• geoff belcher
the sea coast echo

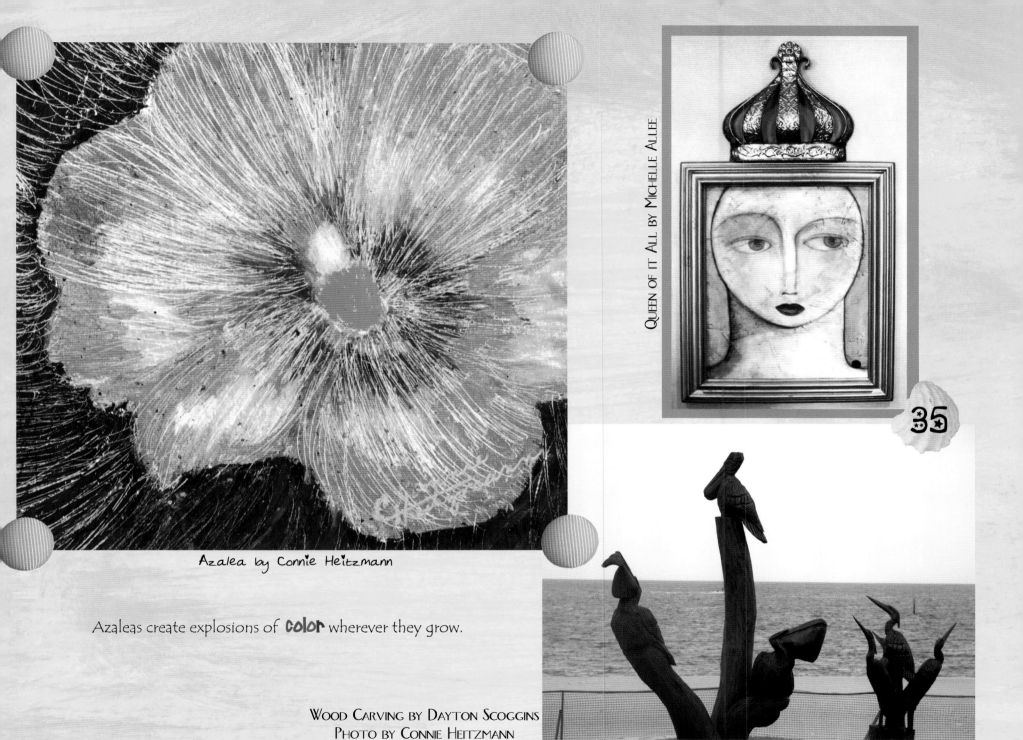

Azalea by Connie Heitzmann

Azaleas create explosions of **color** wherever they grow.

WOOD CARVING BY DAYTON SCOGGINS
PHOTO BY CONNIE HEITZMANN

QUEEN OF IT ALL BY MICHELLE ALLEE

35

PELICAN RESTING BY SYLVIA CORBAN

Sports on the Gulf Coast vary from state to state,
From fishing with the freshest bait,
To those wild hockey games, better not be late.
Baseball is another fun sport,
So is basketball, as long as you stay off the court.
Track and field competitions are a blast,
Just look at our many records from the past.
Football is by far the most popular game,
If you miss out on this, it'll be a shame.
Swimming competitions are popular during the summer,
Just don't get too much water in your ears, or it'll be a bummer.
There are many more sports along the Coast,
Though we try not to boast.
All of these sports are really fun,
Just be careful not to get burned by the sun!

- alex treutel

BAY RATZ FOUNDED BY AMES KERGOSIEN
(CAN YOU GUESS WHO THEY SAY WAS SWITCHED AT BIRTH AT THE HOSPITAL
BECAUSE THEY WERE BORN ON THE SAME DAY?)
PLEASE LET US KNOW.
ARTWORK BY BETTY STECHMANN

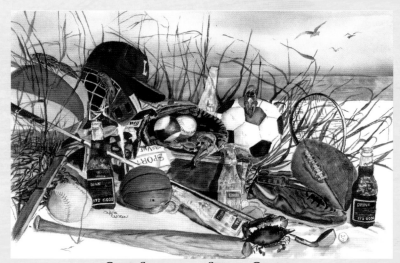

GULF SPORTS BY SYLVIA CORBAN

Hummingbird Moth by Betty Stechmann

Gautier by Linda Theobald

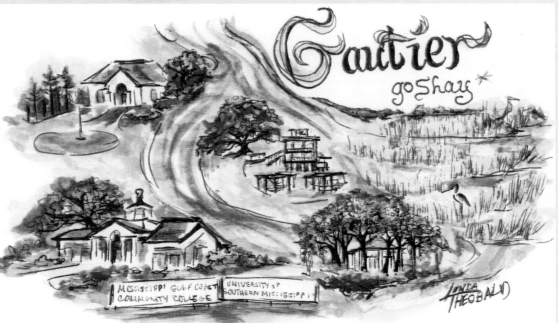

GAUTIER

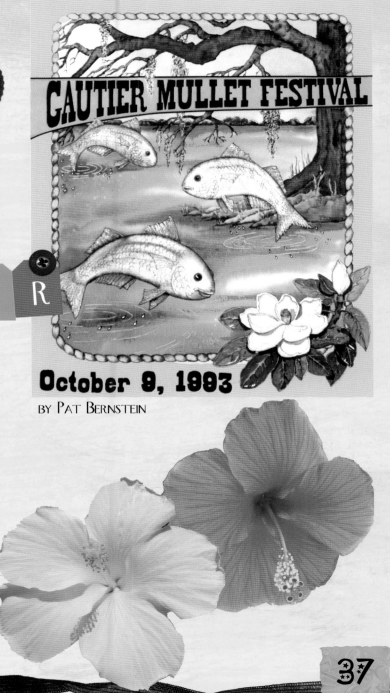

GAUTIER MULLET FESTIVAL

October 9, 1993

by Pat Bernstein

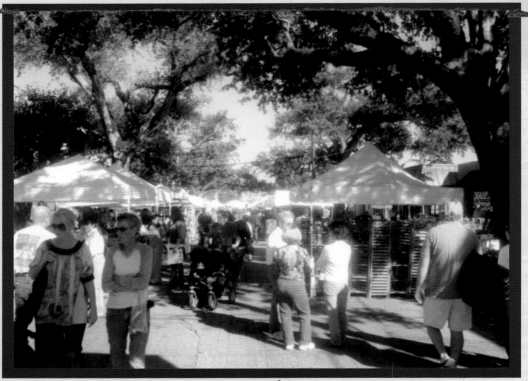

A candid shot by Dena McKee of the Peter Anderson Festival in Ocean Springs held annually on the first weekend in November.

LITTLE ARTHUR,
BETTY STECHMANN'S DAD

FESTIVAL FIDO BY DENA MCKEE

KISSY FISHY BY SYLVIA CORBAN

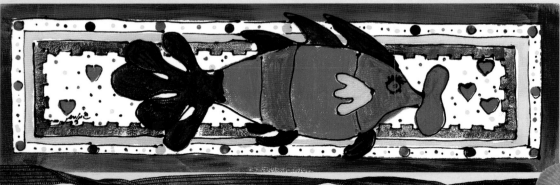

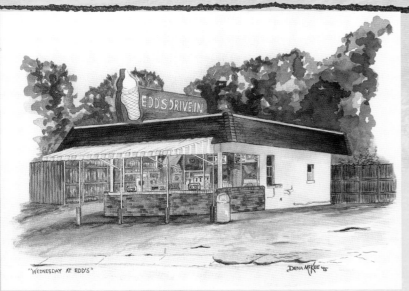

"WEDNESDAY AT EDD'S"

DENA McKEE '95

EDD'S DRIVE-IN BY DENA McKEE

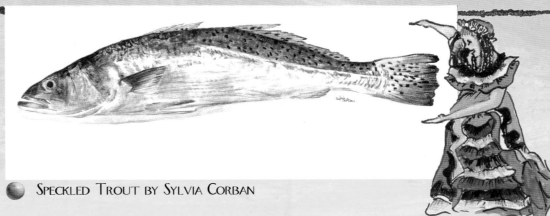

SPECKLED TROUT BY SYLVIA CORBAN

Critter Queen by Karen Renz

wednesday at edd's

Edd's Drive-In has been turning out chili-cheeseburgers, fries, slushes, and shakes in the same manner for at least three generations. No one growing up in Pascagoula in the past forty years has escaped Edd's cuisine. In keeping with its small town tradition, Edd's continues to close on Wednesday. Thank goodness some things never change. - dena mckee

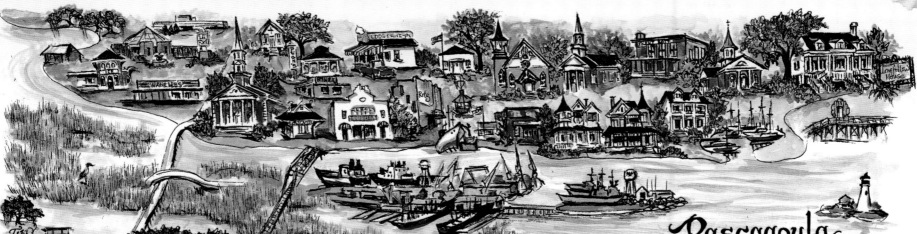

Pascagoula

Pascagoula by Linda Theobald

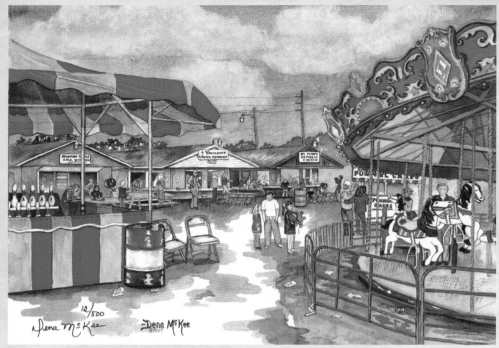

COUNTY FAIR BY DENA MCKEE

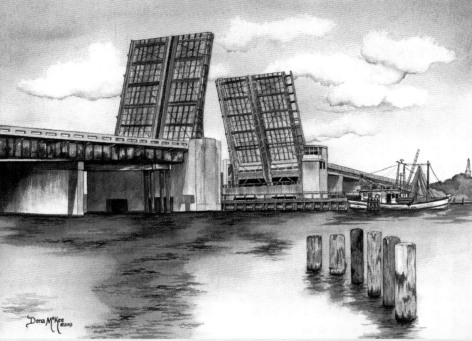

PASCAGOULA DRAWBRIDGE BY DENA MCKEE

Its official name is the Jackson County Blue Ribbon Fair, and once every year in October, most residents of the county make at least one, and sometimes multiple, trips to the fair. Upon arrival, you are welcomed with the mixture of smells from frying funnel cakes, cotton candy and the barnyard aromas. Whether you are there for the gumbo at the church food booth, the judging of the biggest and best vegetables, awards for prize cattle and poultry, or the rides that sometimes give us a thrill or scare, there's something fun for all ages.

- dena mckee

For almost half a century, the Pascagoula drawbridge has welcomed people at the west entrance to the city of Pascagoula. Initial crossings cost twenty-five cents for cars, and later, ticket books were sold, containing passes to cross the bridge with tolls used to pay for the construction. The bridge has seen many sights over the years. It has seen ships being built at nearby Inglall's (now Northrop Grumman) Shipyard, and watched those ships sail out to sea to defend our country. It has carried many workers to their jobs and many serviceman to Naval Station Pascagoula - many frustrated at times when the drawbridge was stuck! It has seen the shrimp fleet head out for their catch, as well as pleasure boats speeding to the islands for a day of fishing and fun. A UFO abduction was even reported below its south side in 1973. The drawbridge was replaced with a new high rise necessary to accommodate the heavy flow of growing traffic in 2003. Some of us miss the old drawbridge.

- dena mckee

Silly Seagulls by Rickey Lewis, Jr.

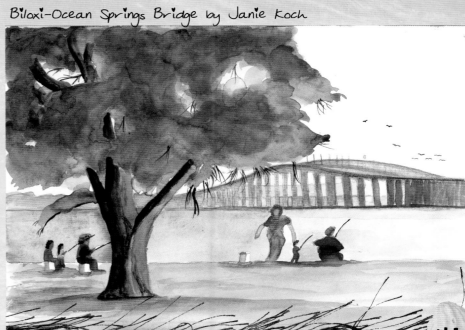

Biloxi-Ocean Springs Bridge by Janie Koch

Ocean Springs by Linda Theobald

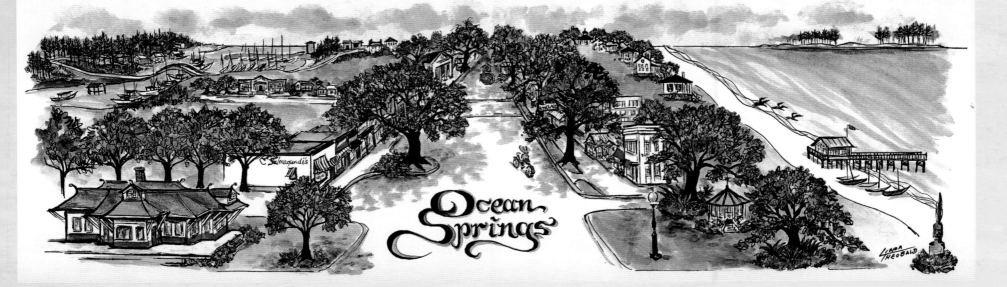

Dancing Dolphins by Penny Adolf

Satchmo's Misbehavin' on the Bayou
by Scott Blackwell

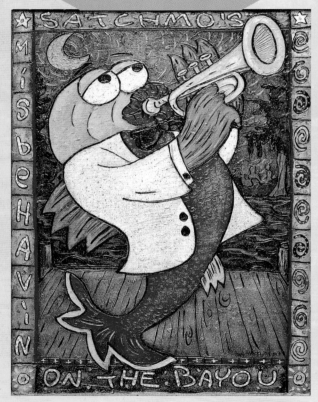

by Betty Stechmann

Star Bright by Connie Heitzmann

Blowing the Blues
by Karen Renz

42

White Kitchen by Dot Copeland

Kickin' Back in the Bay
by Scott Blackwell

BY DWIGHT ISAACS

SHE CRAB

Mid-way between New Orleans and the Gulf Coast, the White Kitchen was literally an oasis in the swamp. After a weekend at the enchanted Gulf beaches, it was one last delaying tactic before returning to the reality of life in the city.

- charles gray

In Flight by Betty Stechmann

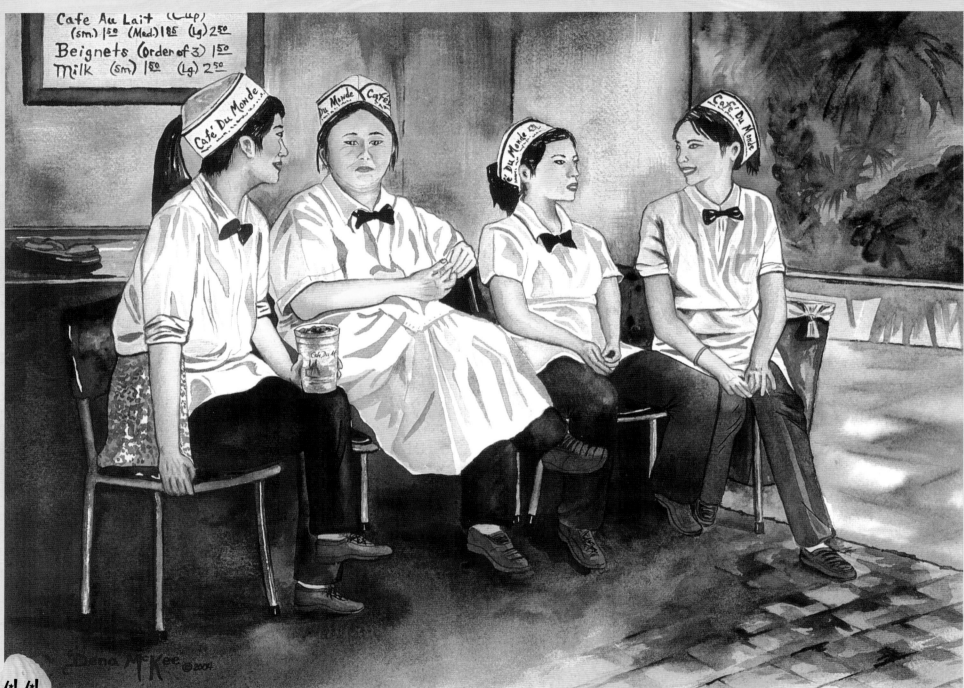

Café Au Lait (Cup)
(sm.) 1⁵⁰ (Med.) 1⁸⁵ (Lg) 2⁵⁰
Beignets (order of 3) 1⁵⁰
Milk (sm) 1⁵⁰ (Lg) 2⁵⁰

COFFEE BREAK AT CAFE DU MONDE IN NEW ORLEANS BY DENA McKEE

44

CREOLE TOMATOES

RICE RIPE BANANAS

SWEET SEEDLESS GRAPES

SWEET NECTA-RINES

RIPE SWEET PEARS

SWEET RED MEAT PLUMS

SWEET SEEDLESS GRAPES

HONEY SWEET TANGERINE

SWEET NAVEL ORANGES SEEDLESS

TEXAS RUBY RED GRAPEFRUIT

TEXAS JUICY

GROCERY BY SYLVIA CORBAN

NEW ORLEANS FARMER'S MARKET BY SYLVIA CORBAN

KAYLIE AT COMMANDER'S PALACE BY CHERIE HYDE

OTHER MAMA BY SPENCER GRAY, JR.

MCKENZIES

Looking for cookies, cakes, and treats,
Got to the corner of so many streets.
McKenzies is there, its cases are filled
With brioche, turtles and pies that are chilled
No matter your mood, the time or the place,
You can find one to put a smile on your face!
So hop on your bike, or a street car might do,
Have one of your favorites or try something new!

- nancy artigues

McKenzies by Jenise McCardell

Lucky Dogs by Jenise McCardell

LUCKY DOGS

I'm hungry, I'm starving
But no time to eat
I'm frantic, I panic
Then I see him on the street!
It's the Lucky Dog man
What a beautiful sight
And his hot dog stand -
Made of red and of white
"Save me," I say, as I run to his spot
"Give me everything on it -
Make it big, make it hot!"
I eat the whole thing in just 4 or 5 bites
I'm so happy right then
But regret it that night!

- nancy artigues

Mardi Gras by Jenise McCardell

FAIRGROUNDS

The track, he said, that's where I'll be.
I'll go before 10 and be home after 3.
A corned beef sandwich and a racing form, too
I'll be set for the day with plenty to do.
I'll bet some to win, to show and to place
He says to us all with a smile on his face.
It makes no difference how they finish or start,
It's the Fairgrounds, itself, that brings joy to his heart.

- nancy artigues

Pontchartrain Beach by Jenise McCardell

New Orleans Fairgrounds by Jenise McCardell

NEW ORLEANS SAINTS - On November 1, 1966 the Saints officially came marching in, as the NFL awarded New Orleans with an expansion team. Even though it was not until 1979 when the Saints had their first non-losing season, they have grown to become an offensive powerhouse, setting season records led by Drew Brees and company. Season ticket sales remain strong.

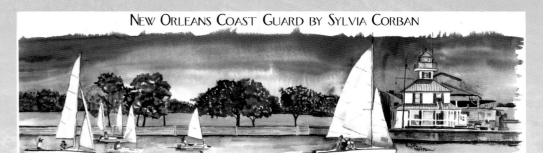

NEW ORLEANS COAST GUARD BY SYLVIA CORBAN

ST. CHARLES STREETCAR BY MARGARET HEITZMANN

NEW ORLEANS HORNETS - October 30, 2002 marked the return of professional basketball to the Big Easy. Ironically, the Hornets' first game was a victory against the Utah Jazz, 100 - 75, who previously called New Orleans home decades earlier, before moving to Utah. The Hornets called Oklahoma City its temporary home, due to Hurricane Katrina, before returning to New Orleans, embracing the culture of the city. The Hornets currently have over 10,000 season ticket holders, which may lead to a long-term deal to keep the Hornets in New Orleans for years to come.

NEW ORLEANS ZEPHYRS - The Triple-A New Orleans Zephyrs are the oldest professional sports franchise in New Orleans. The team began play in 1900 as the Kansas City Cowboys, until 1904 when they changed their name to the Kansas City Blues. Fifty years later, the Blues moved to Denver, Colorado along with another name change to the Denver Bears. In honor of the famous passenger train in 1985, Denver made the final team name change to the Zephyrs. The team pulled into New Orleans for the 1993 season as a minor league baseball affiliate of the Milwaukee Brewers. The New Orleans Zephyrs have changed their affiliation through the years and are currently with the New York Mets.

NEW ORLEANS VOODOO - The New Orleans VooDoo Arena Football team began play on February 8, 2004 on the road against the Philadelphia Soul. The team is owned by New Orleans Saints owner, Tom Benson, and plays in the New Orleans Arena next door to the Louisiana Superdome. The VooDoo are actually the second AFL team to play in New Orleans after the New Orleans Night folded after two seasons in 1992.

ALL SPORTS ARTICLES ON THIS PAGE BY
· matt heitzmann

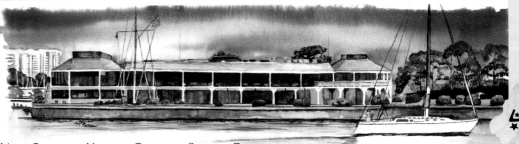

NEW ORLEANS YACHT CLUB BY SYLVIA CORBAN

47

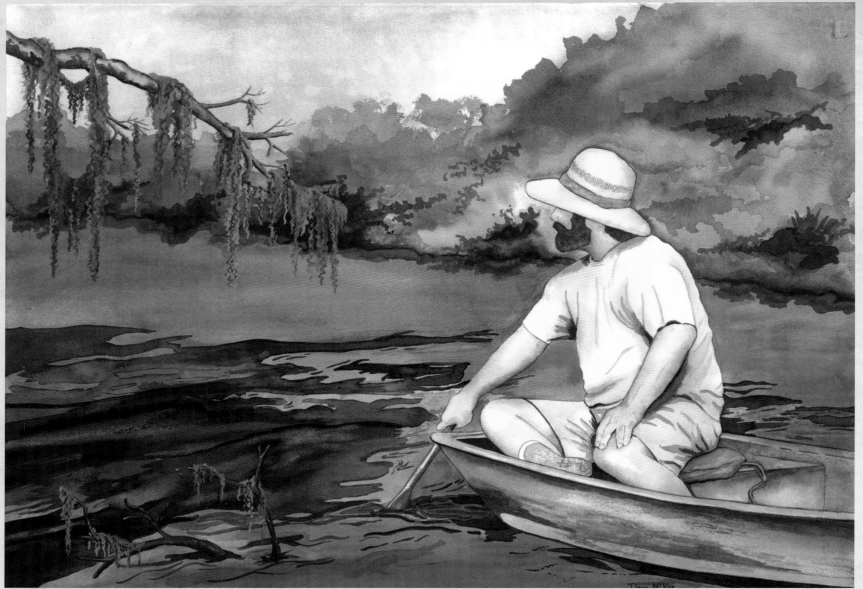

SCULLING CAJUN BY DENA McKEE

"Sculling Cajun" is set in the bayous and swamps of South Louisiana near Breaux Bridge. Sculling is the fine art of moving a boat through the water by paddling a short paddle in a figure eight motion. Sculling was used long before boat motors were introduced and is becoming a lost art.

- dena mckee

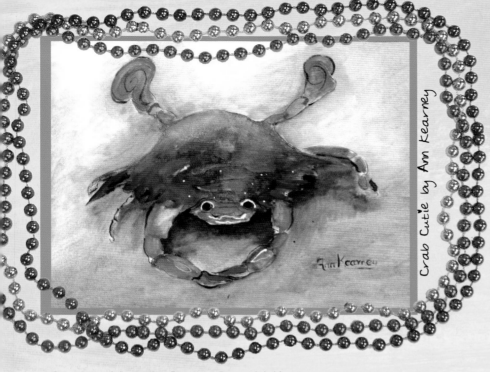

Crab Cutie by Ann Kearney

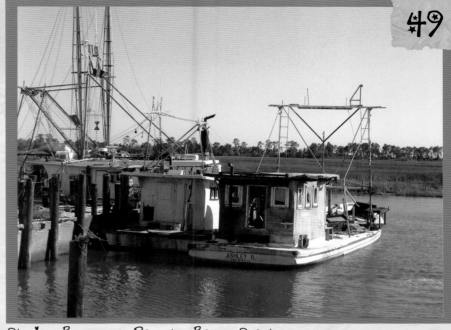

Shrimp Boats at Rest by Betty Stechmann

SPIRIT OF MORGAN CITY BY DENA MCKEE

COURTYARD BEAUTY BY MARCIA ARTIGUES

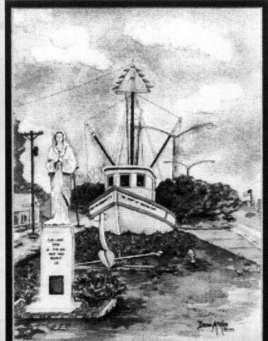

This Shrimpboat
(Spirit of Morgan City)
is in the center of the
highway with "Our Lady
of the Sea" protecting us.

- dena mckee

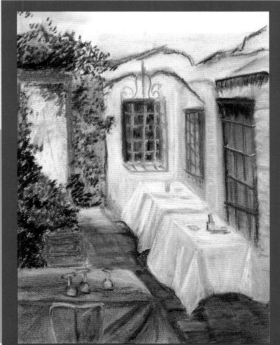

Rocky & Carlos by Jenise McCardell

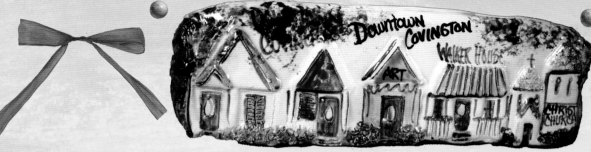

Downtown Covington by Jenise McCardell

Crab Fun by Connie Heitzmann

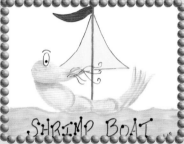

Shrimp Boat
by Dwight Isaacs

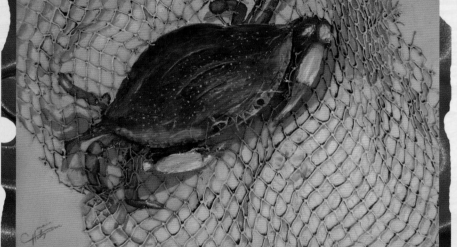

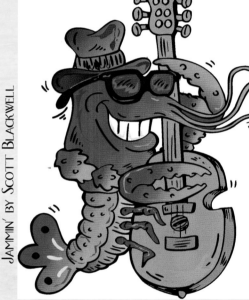

Jammin' by Scott Blackwell

Downtown Baton Rouge by Jenise McCardell

Downtown Mandeville by Jenise McCardell

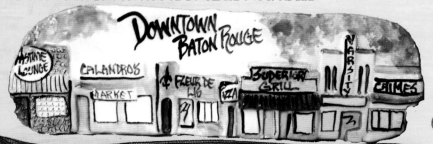

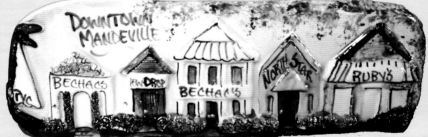

Card Fun! by Sylvia Corban

Oh, the beauty of it all!
Graceful wildlife, wistful breezes,
Spectacular sunsets, serene bayous,
Swaying palms, relaxing beaches,
Tranquil gardens, mighty oaks,
Playful children, gracious parents,
Charming shops, delicious food,
Picturesque homes, inviting churches,
The hidden treasures of the Gulf Coast!

. angelyn treutel

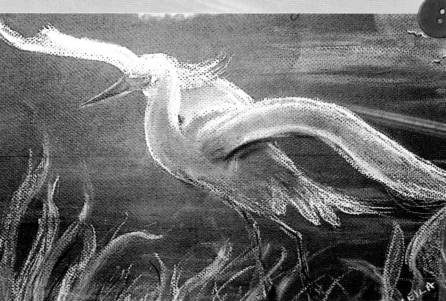

Night Dreams by Betty Stechmann

Palm Posies by Meg Greiner

Pelican Brief by Rickey Lewis, Jr.

51

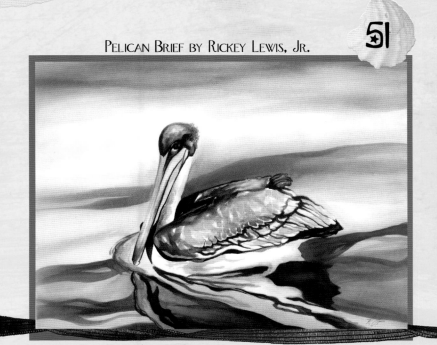

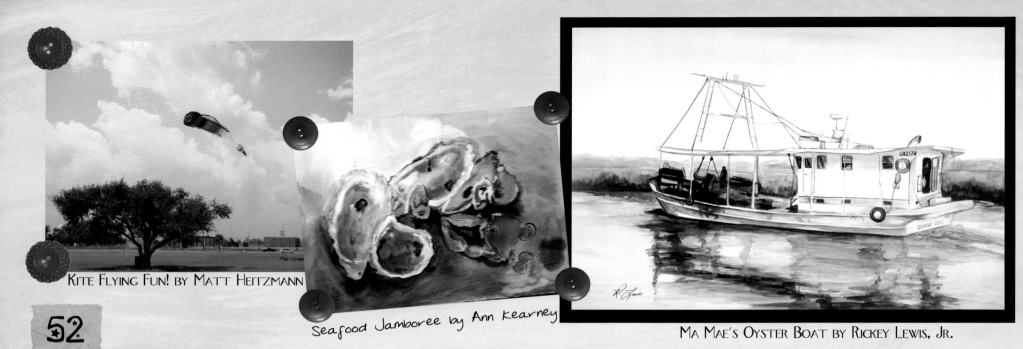

Kite Flying Fun! by Matt Heitzmann

Seafood Jamboree by Ann Kearney

Ma Mae's Oyster Boat by Rickey Lewis, Jr.

The Berwick Lighthouse in Berwick, LA has Morgan City in the background across the Atchafalaya River.

- dena mckee

Berwick Lighthouse by Dena McKee

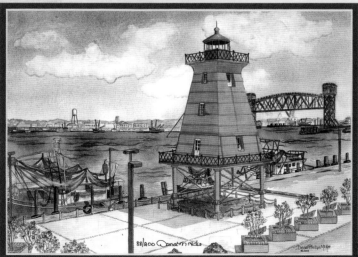

88/200 Dena McKee

"T-Man's on the Bayou" in Stephensville, LA, between Lafayette and Morgan City, was a popular place to reach by boat, for locals to buy gas for their boat rides. This particular place was used in the "De Ja Vu" movie a few years back starring Denzel Washington. It was the location of the bad guy's hideout, where the kidnap victim was held in the movie, and the scene of a large struggle, and the building was blown up for the movie.

- dena mckee

T-Man's on the Bayou by Dena McKee

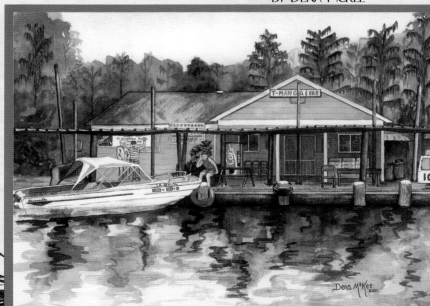

Dena McKee

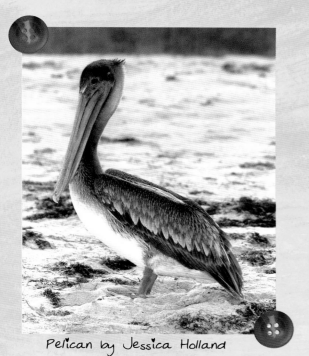

Pelican by Jessica Holland

Flying Scots by Martha Merrigan

Fairhope and Point Clear by Linda Theobald

Fairhope

Point Clear

Egret by Barbara Brodtmann

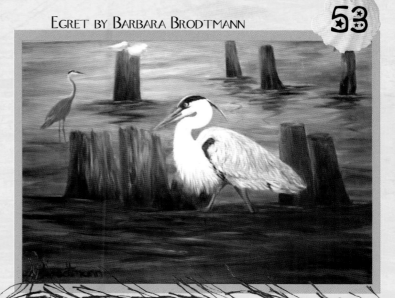

53

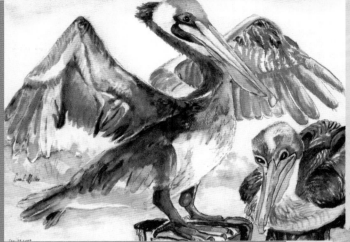

Middle Bay Lighthouse is a landmark in Mobile Bay. This image of the lighthouse can be seen at the Estaurium on Dauphin Island over the Mobile Bay Aquarium. It is reproduced in a 13x8 foot size.

- dave miller

These two pelicans are about to rest after dinner. The fishermen, crabbers and oystermen are very generous to the birds. At times you can see a dozen or more birds around their boats.

- linda miller

54

Blue Crabs were two crabs caught in the Mississippi Sound off Dauphin Island.

- linda miller

Sand Island Lighthouse stands at the mouth of Mobile Bay. For locals on the water, it is a symbol of safety, that home is not far away.

- dave miller

BLUE STRIPED GRUNTS BY LINDA MILLER

Blue striped Grunts are talkers. They make a grunting sound by grinding their teeth together, thus the name Grunts.

- linda miller

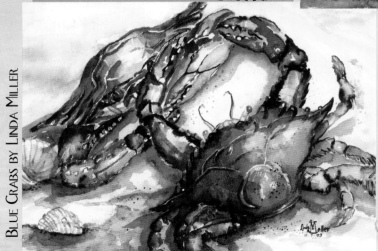

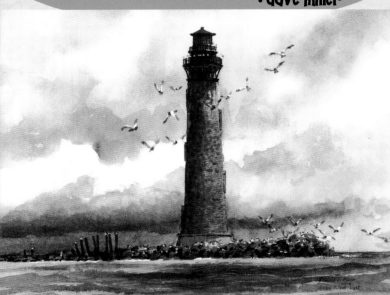

JUBILEE I: MR. "SONNY'S" JUBILEE BY TERRI KELLER

The call goes out around the town—
It's Jubilee time, get rid of your frown!
An amazing time on the Mobile Bay,
Bring your bucket, find your way,
To the water, to the shore.
Grab your net and plan for more
Crabs, flounders, shrimp and fish,
A bountiful harvest, just make your wish.

- angelyn treutel

Standing the test of time and hurricanes, Jemison's Bait & Tackle, located on the causeway between the Mainland and Dauphin Island, supplies fishermen, oyster men and shrimpers with bait, tackle and refreshment. Some folks say it's been around over eighty years. I passed it coming and going for nearly half that long, before capturing it in this painting!

- terri keller

As the painting of this muddy water jubilee developed, I attempted to capture the excitement of just "being there" through the eyes of my friend, the late Mr. "Sonny" Wolfe. He had a passion for floundering and loved the jubilees on the Eastern shore of Mobile Bay. Mr. Sonny always delighted in talking endlessly about his faith, family and fishing.

- terri keller

JEMISON'S BY TERRI KELLER

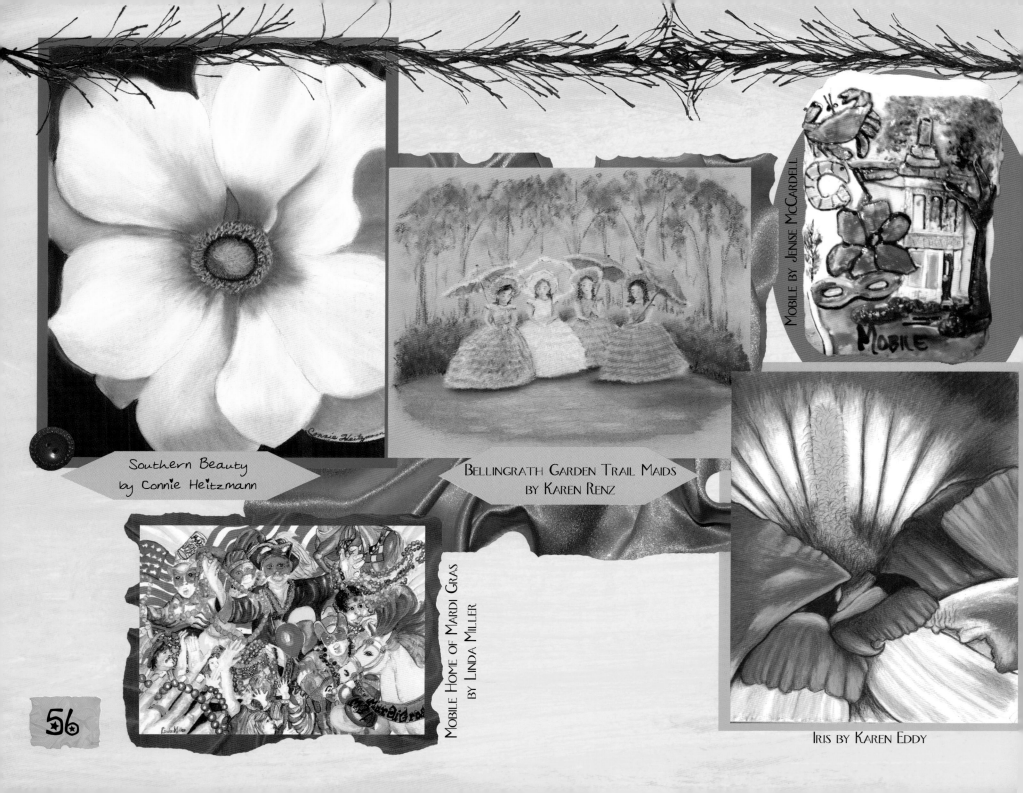

Southern Beauty
by Connie Heitzmann

Bellingrath Garden Trail Maids
by Karen Renz

Mobile by Jenise McCardell

Mobile Home of Mardi Gras
by Linda Miller

Iris by Karen Eddy

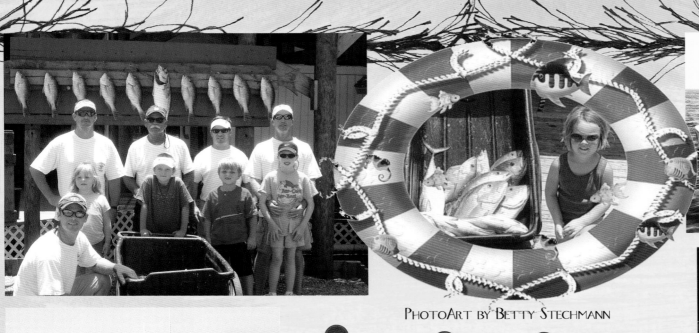

PhotoArt by Betty Stechmann

ORANGE BEACH
ALABAMA

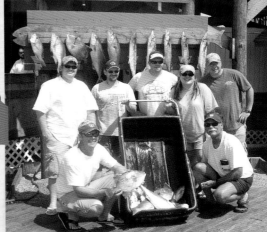

Tootie Green's Yellow Broom

Orange Beach is the Red Snapper Capital and the home of Tootie Green's Yellow Broom - Hope to see you soon!

PHOTOS COMPLIMENTS OF SUSAN CAPPAR

florida

F U N

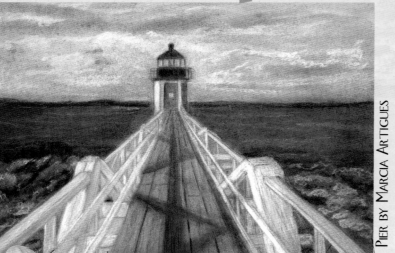

PIER BY MARCIA ARTIGUES

58

FLORA–BAMA BY DAVE MILLER

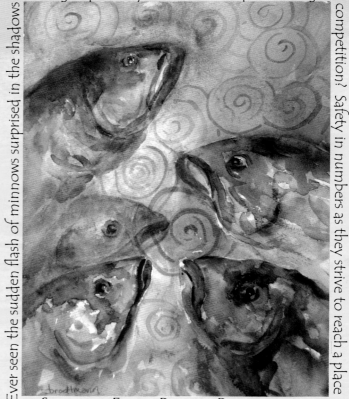

Ever seen the sudden flash of minnows surprised in the shadows

SCHOOL OF FISH BY BARBARA BRODTMANN

flora-bama is located in the Panhandle of Florida and in Alabama. Each year the two states have the Mullet Toss, to see who can toss a dead mullet the longest distance into the other state.

· dave miller

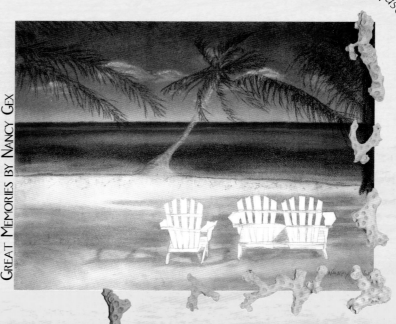

GREAT MEMORIES BY NANCY GEX

just beyond the threat. **· suzi hand**

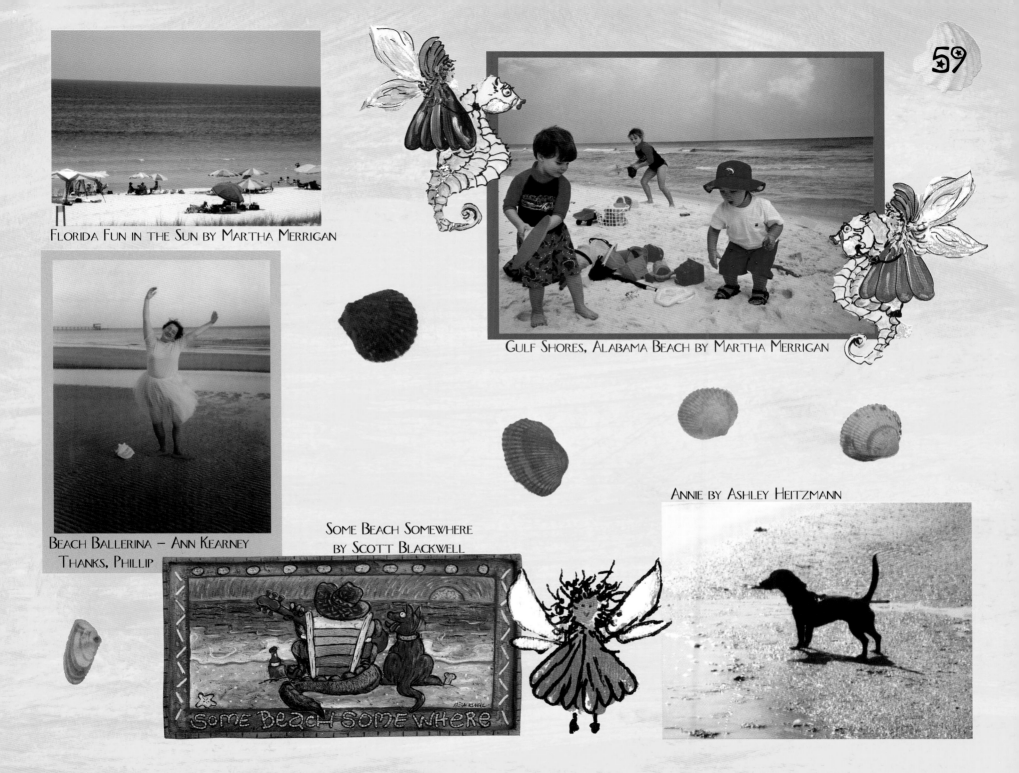

Florida Fun in the Sun by Martha Merrigan

Gulf Shores, Alabama Beach by Martha Merrigan

Beach Ballerina – Ann Kearney
Thanks, Phillip

Some Beach Somewhere
by Scott Blackwell

Some Beach Some Where

Annie by Ashley Heitzmann

FROM LINDA LADNER TOMASICH TO MARILYN HEITZMANN CARDENAS

FROM ONE GOOD SKATE TO ANOTHER, BE MY Valentine

Made in U.S.A.

M.B. Toyland,

Dear Little Friend,

Thank you for the very nice letter you wrote me at Maison Blanche. I hope that I can read it on Radio Station W L M B at 5:30 Tues. and that you'll be home to hear it

Your Friend, Santa Claus

CHRISTMAS ON THE WATER BY LINDA THEOBALD

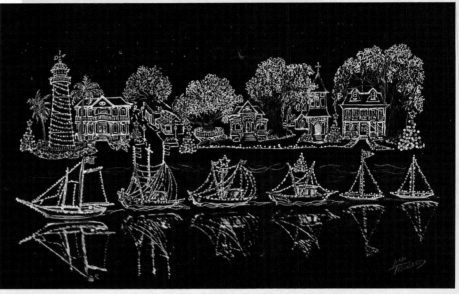

FROM MARIE ELENA VASSALLI STRONG TO MARILYN HEITZMANN CARDENAS

I'M READY TO JUMP

INTO YOUR ARMS, Valentine

Made in U.S.A.

celebration

When you live on the Gulf of Mexico
Each day is a celebration
Just to wake up in Paradise
With the brilliant blue sky and the sun in your eyes
And the Gulf Coast to ease your frustration.
There are special days we will always remember
Like Birthdays, Valentine's Day and Christmas time
With Santa and his sleigh
Or a happy birthday
And Cupid's arrows flying just fine.

- karen eddy

FLASH GORDON FROM JUDY HEITZMANN TO MARILYN HEITZMANN CARDENAS

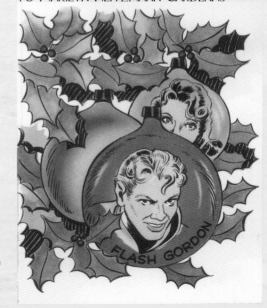

FLASH GORDON

CAJUN SANTA CLAWS BY DWIGHT ISAACS

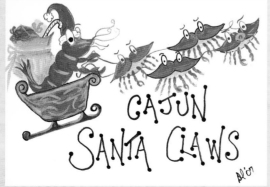

CAJUN SANTA CLAWS

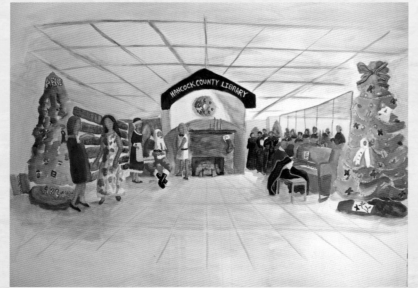

CHRISTMAS AT HANCOCK COUNTY LIBRARY BY JANIE KOCH

Betty Stechmann
Treasures
Art, Photography,
Photo Art Design & Author
P.O. Box 2206
Bay St. Louis, MS 39520
Bettystech@yahoo.com
228.216.4118

BETTY STECHMANN

BETTY STECHMANN AND CONNIE HEITZMANN WOULD LIKE TO THANK THE FOLLOWING GUEST ARTISTS, PHOTOGRAPHERS AND WRITERS WHO CONTRIBUTED TO THIS BOOK.

CONNIE HEITZMANN AND FRIEND

Connie Heitzmann
Treasures & Memories
Art, Photography,
Writer & Author
P.O. Box 2206
Bay St. Louis, MS 39520
ctreasures@mchsi.com
cheitzmann@mchsi.com
228.342.1352

Alex Treutel
Guest Writer,
Special Friend and Thanks

Alice Moseley Folk Art Museum
Tim Moseley
214 Bookter St.
Bay St. Louis, MS 39520
228.467.9223

Angelyn Treutel, CPA
Guest Writer
Treutel Insurance
Agency, Inc.
401A Hwy 90
Bay St. Louis, MS 39520
Angelyn@treutel.com
228.467.5662

Ann Kearney
Guest Water Color Artist,
Guest Writer
213 Main St.
Bay St. Louis, MS 39520
228.671.9531

Ann O'Toole
Guest Writer
ann.no21@gmail.com

Barbara Brodtmann
Guest Artist
228.467.8480 (@Sheri
Armstrong - Behold Fine Art)
BarbaraBrodtmann@aol.com
www.Katrinaartists.com

Beth Coleman
Guest Photographer
Special Thanks

Betsy Gagnet
Guest Writer
Special Thanks

Bonné Vallery
Guest Artist, Guest Writer
7075 Comanche St.
Kiln, MS 39556
228.324.4574

Charles H. Gray
Guest Writer
Hancock County
Historical Society
www.Hancockcounty
historicalsociety.com
228.467.4090

Cherie Hyde
Guest Artist
Holy Trinity School
chyde@holytrinitycatholic.net
228.342.1134

Christina Harrelson
Digital Expert, Guest Editor,
Artist & Business Express
- Manager
998B Hwy 90
Bay St. Louis, MS 39520
artistandbusines@bellsouth.net
228.467.5833

Christy Carter
Guest Writer

Daisy Karam-Read
Author, Guest Writer
*From Manhattan to Mississippi -
A New Yorker Falls in Love with
the South*
readatsea@aol.com

David Miller
Guest Artist, Guest Writer
Pelican Bay Arts
P.O. Box 468
Dauphin Island, AL 36528
dmiller1@centurytel.net
251.861.2422

Dayle Lewis
Guest Artist / Woodcarver
Thanks from our Coast

Dayton Scoggins
Guest Artist / Woodcarver
Thanks from our Coast

Dena McKee
Guest Artist, Guest
Photographer, Guest Writer
P.O. Box 2040
Pascagoula, MS 39569-2040
www.denamckee.com
dena@denamckee.com
228.217.3888

Devon Weston
Guest Artist,
Special Friend and Thanks
Clay Creations
220 Main St.
Bay St. Louis, MS 39520
claycreationsllc@yahoo.com
228.466.6347

Dot Copeland
Guest Artist
The Painters Place
Diamondhead, MS 39525
228.216.2999

Dwight Isaacs
Guest Artist
Shabby Chic
213 Main St.
Bay St. Louis, MS 39520
228.216.9613

Jenise McCardell
Guest Artist
Clay Creations
220 Main St.
Bay St. Louis, MS 39520
claycreationsllc@yahoo.com
228.466.6347

Karen Renz
Guest Artist,
Guest Cover Artist
Karen Anne's
School of Fine Art
Bay St. Louis, MS 39520
karenannerenz@yahoo.com
228.467.0076

Linda Theobald
Guest Artist
lindatheobaldart@gmail.com
www.lindatheobaldart.com
228.255.9796

Frank Davis
Guest Author,
WWL Television Personality.
Cajun and Creole Cooking, and
Sweet Mary Clare
Fishing News Letter
http://www.wwltv.com
frankd@frankdavis.com
504.884.4242

Jessica W. Holland
Guest Photographer
jess.holland15@gmail.com
www.kissthesky.us
601.889.1518

Kathe Calhoun
Guest Artist
Katheart@mchsi.com
228.467.9042

Lori Gordon
Guest Artist
(www.thekatrinacollectionby
lorigordon.blogspot.com)
lorikgordon@gmail.com
228.342.0872

Geoff Belcher
Guest Writer
Sea Coast Echo Newspaper
gbelcher@seacoastecho.com
Phone: 228.467.5474
Fax: 228.467.0333

Jimmy Loiacano
Guest Photographer

Kathy & Ron Pinn
Guest Photographers,
Guest Writers
That Cute Little Shoppe
634 Hwy 90
Waveland, MS 39576
228.467.3922
www.thatcutelittleshoppe.com
Kathy@thatcutelittleshoppe.com

Mai Sanders
Guest Artist
Waveland, MS
Behold Fine Art - Sheri
228.467.3429

Heather Wagar
Guest Artist
La Provence Collection
207 E. Scenic Drive
Pass Christian, MS 39571
228.452.3943

Jo Ann Hille
Guest Artist
Photo of Jo in one of her great
productions :)
avemariablue@yahoo.com

Kay Gleber
Guest Writer, Guest Editor

Marcia Artigues
Guest Artist
Special Thanks

Janet Buras
Guest Photographer
Special Thanks
principal@holytrinitycatholic.net

John M. Rosetti, III
Guest Writer
Special Thanks

Ken Murphy
Guest Photographer,
Back Cover of Book
My South Coast Home,
*Photographs of the Mississippi
Gulf Coast* and *Mississippi,
Photographs by Ken Murphy*
P.O. Box 3898
Bay St. Louis, MS 39521
www.kenmurphysouth.com
kenmurphysouth@aol.com
228.216.0465

Margaret Heitzmann
Guest Artist
Special Thanks to Mom

Janie Koch
Guest Artist, Guest
Photographer, Guest Writer
Memories
P.O. Box 2206
Bay St. Louis, MS 39520
JanieK@cableone.net
228.452.3266

Karen & Paul Eddy
Guest Photographers,
Guest Artist and
Guest Writer
keddy55@gmail.com

Linda Miller
Guest Artist, Guest Writer
Pelican Bay Arts
P.O. Box 468
Dauphin Island, AL 36828
dmiller@centurytel.net
251.861.2422

Margo Frommeyer
Guest Writer
Special Thanks
P.O. Box 6082
Diamondhead, MS 39525
228.493.5588

Marie Klein
Guest Artist
Special Thanks

Marilyn Heitzmann Cardenas
Guest Scrap Booker
Special Thanks

Meg Greiner
Guest Artist
Independence Elementary
School
150 S. 4th St.
Independence, OR 97351
greiner@aol.com
503.606.2180

Nereids
Special Thanks
Dolores Richmond, Captain
Mary Ann Pucheu,
Charles Johnson, Jr.
Laura Lacour

Sandy Belcher
Guest Photographer
southernmiss@
bellsouth.net
Waveland, MS
228.467.1809

Marlin Miller
Guest Artist / Woodcarver
Thanks from our Coast

Michelle Allee
Guest Artist
mallee@cableone.net
228.452.1365

Orange Beach Friends
Special Thanks to our Friends!

Scott Blackwell
Guest Artist
Mombo Graphixs
712 Hwy 90
Waveland, MS 39576
www.mombocompany.com
Mombocompany@aol.com
228.466.2551

Martha Merrigan
Guest Photographer,
Guest Writer, Guest Editor

Pat Bernstein
Guest Artist,
Guest Photographer
prbernstein@bellsouth.net

Mimi Loup Brown
Guest Artist
Long Beach, MS 39560
228.324.4971

Patsy Seeling
Guest Photographer,
Friend and Special Thanks
to our "Class Mermaids"

**Rev. Sebastian
Myladiyil, SVD**
Guest Artist, Guest Writer
St. Rose de Lima - Pastor
Necaise Ave.
Bay St. Louis, MS
228.467.7347
sebymy@hotmail.com

Mary Ladner Benvenutti
Guest Writer
Special Thanks

Nan & Dick Ehrbright
Guest Writers
NPEBRIGHT@aol.com

Penny Adolf
Guest Artist
Independence Elementary
School
150 S. 4th St.
Independence, OR 97351
adolfpen@msn.com
503.999.0576

Spencer Gray, Jr.
Guest Artist, Cartoonist, Sculptor
220 Main St.
Bay St. Louis, MS 39520
sales@spencergrayjr.com
228.324.8106

Mary Miller
Guest Artist
The Glass Bear
kirk_m2000@charter.net

Nancy Artigues
Guest Writer
Special Thanks

Rachel Winters
Cover and Interior
Graphic Design
Greensburg, IN
Thank you very much, Rachel,
for everything!

Suzi Hand
Guest Writer,
Special Friend and Thanks
Houston, TX

Matt & Ashley Heitzmann
Guest Writer,
Guest Photographers
Special Thanks

Nancy Gex
Guest Artist
Special Thanks

**Matt Heitzmann,
Matt Barrett, Terry Snell**
TuneRay.com
Where the Music Lives!

Nancy McCardell
Guest Artist
Clay Creations
220 Main St.
Bay St. Louis, MS 39520
claycreationsllc@yahoo.com
228.466.6347

Rickey Lewis, Jr.
Guest Artist, Guest Photographer
www.myspace.com/paint4pennies
rickeylewis@yahoo.com
rlewis@pc.k12.ms.us

Sylvia Corban
Guest Artist
Diamondhead, MS
228.586.0070

Tazewell Morton
Guest Artist
www.tazewellsworld.com
Meg@tazewellsworld.com
251.422.1556

Terri Keller
Guest Artist, Guest Writer
3700 Gulf Court
Theodore, AL 36582
terripittmankeller.blogspot.com/
kell7872@bellsouth.net
251.443.6815

Tish Haas Williams
Guest Writer
Hancock County
Chamber of Commerce
www.hancockchamber.org

Tootie Green's Yellow Broom
Orange Beach, AL
Special Thanks

Tracy Winters
Publisher
Winters Publishing
P.O. Box 501
Greensburg, IN 47240
www.winterspublishing.com
812.663.4948

Vicki Niolet
Guest Photographer,
Author – *Parting Shots*
and *West Side Stories*
www.vickiniolet.com
vniolet@earthlink.net

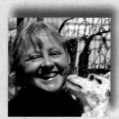

Our Special Thanks To:

All of our Family Members
All Gulf Shores Friends
All Neighbors and Friends
 They are the joy of our lives!
All Orange Beach Friends
All Disney Friends
Alice Moseley Folk Art Museum -
 Tim Moseley
Biloxi Art Association
Hancock County Artist Association
Hancock County Historical Society
Hancock Chamber of Commerce
Hancock County Libraries
Mississippi Arts Commission Art Grants
1 Music Cares - Music Grants
Hancock County Tourism Department
Harrison County Tourism -
 Patricia Zdziemborski
Pass Christian Art Association
Pass Christian Library

And also:

Anne-Flore & Ludovic - Villeurbanne, France
Ames Kergosien
Angel Ministry
Ashley Wiseman - Katrina Angel Smiles
Artist & Business Express - Theresa Pope
Antique Maison - Sylvia and Ed Young & Gang
All Artists, Photographers, Writers Everywhere
All Dauphin Island, AL Friends
All Downtown Artists
Bay Books - Kay and Family
Bay Bridge Festival
Bay Cleaners - See Kyle and gang
 for the cleanest books in town!
Bay High
Bay St. Louis & Waveland Highway 90 Artists
Bayou Country - Slidell, LA
 Our Camellia City - Hope to see you soon!
Behold Fine Art and Framing -
 Sheri Armstrong
Beach Comber - Special Thanks
Bezou Family
Biloxi Elite Swim Team -
 They are the BEST! You Go!
 USA Competitive Swim Team
 City of Biloxi Parks and Playgrounds
Blessing of the Shrimp Fleet Festivals
Boxx Family

Bob Heitzmann
Bobby Brown
Brandi Jaquillard
Captain Dick Cappar, Mates and Anglers
Captain Patrick Ivie, Mates and Anglers
Charles H. Johnson, Jr.
Chris Funt
Christina Harrelson - A HEARTFELT AND
 VERY SPECIAL THANKS!
Courtney Wiseman -
 Katrina Angel Smiles
Discovery Cay - Atlantis, Bahamas
Dina, John and Luke Rosetti
Dixie Belcher
Dottie Scheurbaum & Crew
Donna Davenport - Loft Framing
Donna Warburton
Earthpathyoga & Health Friends
Ed Grotkowski and Our Gang
Eddie Coleman
EJM - Biloxi
Ellis Anderson
Frank Davis & Mary Clare
 WWL-TV and great author
Gary Taylor - Bridge Tickets
 from Larry Larroux
Gulf Coast News
Hardrock - Biloxi - Love All, Serve All
 Thanks for their mission!
Hop to the View - Biloxi Friends
Ira & Benni Hatchett - WBSL 1190
 ... the Blue Beat of the Bay ...
 ihatchett@Bellsouth.net
Irene Thomas Berry
Jane Pizzolato, Kim & June
Janie Koch & Family - Our Special Friends
Jill & Grey Sterrett - Katrina Angels
Joan & John Glenn
Josettes
Judith Renshaw
Karen Phillips
Karen Renz - Great Cover Artist
Katrina Christmas Angels Project
Ken Murphy -
 Great Back Cover Photograph
Kylie Sievery -
 Orange Beach Friend
La Provence - Suzanne Wagar
Lili Stahler
Linda Buckley
Linda Graffeo

Lucy Markel - Waveland, MS
Lulu's Marina - Gulf Shores, AL
Nella's Doughnuts - The Meeting Place
Marianne Pluim
Marie Jose and Family - Lyon, France
Mary Ann Becker-Haggard & Mike
Mary Ann Pucheu
Maxwell
Mazie Pizzolato
Michael Tracy
Murphy Family
Nancy Behrens
NASA -
 Celebrating 50 years. Congratulations!
"Our Class"
"Our Class Mermaids"
Our Alabama Friends
Our Florida Friends
Our Louisiana Friends
Our Texas Friends
Pat Bernstein - Digital Help
Pat Murphy Archives
Peter Daugherty
P. J. Mauffray
Rick Dobbs - Unreal
Rick Killian and Crew
Saint Joseph Academy Gal Support
Saint Stanislaus
Sea Coast Echo Newspaper
Shabby Chic
Sophia, Nicholas and Maria
Special Friends - You know who you are!
St. Augustine Seminary
Stacy Spangler, Rick & Katrina Angels
Susan & Brian Wiseman & Katrina Angels
Epis. Church of Nativity - Grand Junction, CO
Christmas Project Visionaries
Sweet @ Inc.
Tea Tillman
The Caboose Fine Art
The Oyster House -
 We love our favorite Oyster House
Tootie Green's Yellow Broom -
 Orange Beach Friends - Please tell Tootie
 and the gang we said "Hi."
Tracy, Phyllis and Rachel Winters
Treutel Insurance
Uptown Interiors
Zeke's Landing Marina and Friends

... AND ESPECIALLY YOU!

64